SEACOAST MAINE

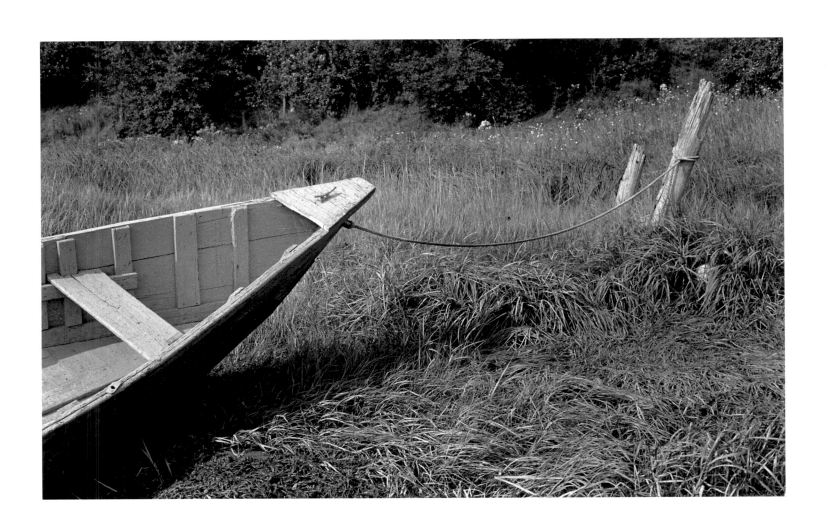

SEACOAST MAINE

PHOTOGRAPHS BY GEORGE TICE

INTRODUCTION BY JOHN K. HANSON

An Imago Mundi Book

DAVID R. GODINE · PUBLISHER

BOSTON

An Imago Mundi Book
published in 2009 by
DAVID R. GODINE · *Publisher*
Post Office Box 450
Jaffrey, New Hampshire 03452
www.godine.com

LIBRARY OF CONGRESS CATALOGING-IN-PUBLICATION DATA

Tice, George A.
Seacoast Maine / photographs by George Tice ; introduction by John K. Hanson. — 1st ed.
p. cm. — (An imago mundi book)
ISBN 978-156792-376-6 (HC)
ISBN 978-156792-378- (SC)
1. Atlantic Coast (Me.)—Pictorial works. 2. Landscape—Maine—Atlantic Coast—Pictorial works.
3. Maine--Pictorial works. I. Title.
F27.A75T43 2009
974.10094′60222—dc22
2008042263

PAGE 2: *Rowboat, Thomaston, 1970*
OPPOSITE: *Gulls off Port Clyde, 1971*

FIRST EDITION, 2009
Printed in the United States of America

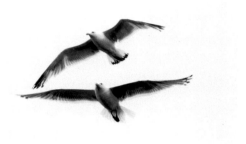

To my son Christopher

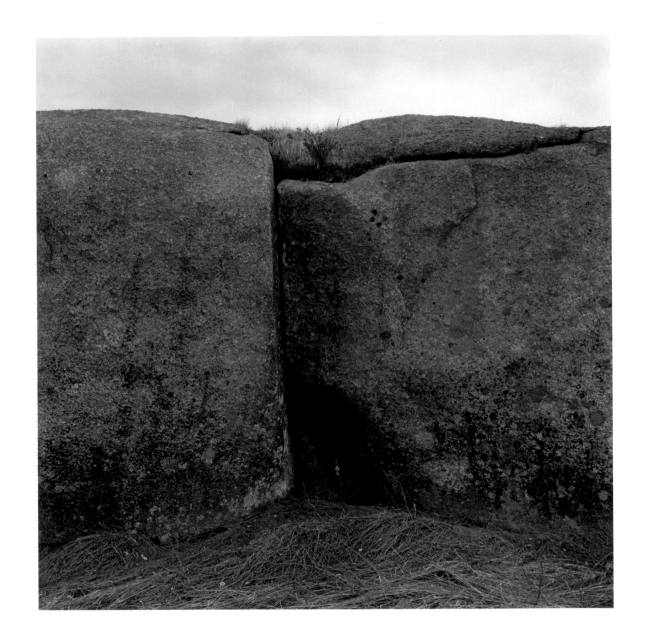

Russ Island, 1971

INTRODUCTION

A few years ago, an art museum in Katonah, New York, held a summer show featuring the work of Maine artists. From the perspective of a summer-in-the-city resident of Manhattan, the images of Maine by the likes of Louise Nevelson, Rockwell Kent, Frederick Edwin Church, Fairfield Porter, the Wyeths, and others make the state seem a yearned-for place often remote in time, beauty, and subject matter. In other words, an unattainable ideal, a myth – and that is how the exhibition was described in the catalogue *The Myth of Maine as America's Eden*.

The photographs by George Tice in his *Seacoast Maine* also portray a Maine of myth. His portrayal is not of yearning but of belonging – of truths greater than reality. Yes, he has images highlighting the permanence of Maine's rocky coast, the constant movement of the sea, and the efforts of the people who live and work there. But it is not the soft summer light that bathes his extraordinary black-and-white images of life on the coast; it is the colder light of the working day. His photographs show the nobility of tools, the demands of hard work, the challenges of place.

George Tice is from New Jersey. He lives in the Atlantic Highlands area near Sandy Hook Bay – the southern approaches to New York Harbor – though he is very much tied to Paterson, a working-class town in northern New Jersey. Paterson is the subject of two of his earlier books, which reveal a city of immigrants, now-closed mills, and a majestic, seventy-seven-foot waterfall that once powered the mills that were the source of the city's prosperity. His photographs project a stillness that seems to bore into Paterson's core. They inform the details of life there, not with the morbid fascination often seen in the work of other contemporary photographers, but with a more sympathetic "you are there" point of view. The grit is neither glamorized nor fetishized. The photographs of life in Paterson are caught in great detail and in great light.

It is this eye and sense of place that Tice brought with him when he first started to photograph Maine in the summer of 1970, not long before I, with my own New Jersey roots, moved to the state. The photographs in this book span my life in Maine.

I didn't realize it at the time, but it was his early photographs of Maine that helped establish

my personal mythology of the state, my understanding of life on the coast, my sense of place. These images of his, especially the beautiful geometric shot of the porch and the sea on page 11, were on display in galleries along the coast during my first summer there. They helped form my lasting image of Maine's immediate past.

The early seventies were an amazingly creative time along the coast. *Maine Times*, founded by Peter Cox and John Cole in Brunswick in 1969, chronicled the changes; WBLM, "The Blimp," broadcasted the rock-'n'-roll soundtrack; Robert J. Lurtsema intoned the meaning of the classics every morning on public radio, and residents all along the coast from Kittery to Calais began using the traditions of Maine life as a starting point for the new "post-industrial society" that John Cole described and predicted.

The Maine coast was alive with activity. The boatbuilding industry, which had almost died, came to life through the combination of the newly imposed two-hundred-mile territorial limit to keep out foreign fishing vessels and encourage the domestic fleet, and a growing interest in workboat-derived pleasure boats. Old shops were revived and, more importantly, new ones were established. The organic farming and gardening movement started to take root. New publishing ventures, such as *Maine Antique Digest*, *Farmstead*, and *WoodenBoat* were passing on the knowledge of traditional ways and technologies, reenergizing these venerable crafts for new and growing audiences. This revival of old-time traditions helped build the more prosperous Maine of today.

George Tice's photographs speak to me of that era. A goodly number of the photographs in *Seacoast Maine* depict the end of winter or the hint of spring. The trees are bare, there's dirty snow by the edge of the road; this could be the state at what might seem its ugliest. To me, though, this time of year and Tice's photographs speak of a coming renewal. There's a feeling of expectancy: Behind that shop door, a new boat awaits launching as soon as the snow melts; down in Stonington, the lobster boats, ashore for the winter, are poised on the brink of a new season. The long period of dormancy is almost over.

George Tice's images of the sea and the rocky shore are timeless. Even photographs taken in the 1970s of people living and working are as right today as they were thirty-five years ago. The men at work on the fish pier (page 29), the man shoveling bait (page 81), Bertram Peabody and

his son digging clams (page 34) – these photographs and others like them could have been taken today. But then again, they couldn't. The photographs Tice took of the working fishing harbors in the early 1970s were of a time just before the boom began. Yes, the moored boats were usually lobster boats, but there is nevertheless a big difference between those then and those now. The lobster boats of the 1970s were smaller and made of wood, the last generation so built. They were narrower, had engines of much less horsepower, and were designed to fish fewer traps.

Look at Tice's photograph of lobster boats rolling in surge off Monhegan Island (page 21). A wonderful combination of motion and stillness, the image is also a valuable documentation of a working fleet before the wider, bigger, turbo-charged, diesel-powered fiberglass boats became the norm. Today's harbors have more boats, both commercial and recreational, than those depicted in Tice's earliest Maine work. His art documents an earlier, a simpler, and perhaps a happier era before GPS replaced the compass and dead reckoning.

There have been many changes along the coast of Maine in the last thirty-five years. Because of technology – first there was radio, then television, then video, then cable TV, and now the Internet – Maine is no longer as isolated as in decades past. Dance tunes, YouTube, Facebook, and bloggers speed through Maine's ether in a nanosecond, just as everywhere else in the world. This state, however, has not given up its distinction of being a separate, distinctive place. Looking at these images by George Tice, I can still see what makes coastal Maine timeless, as appealing and seductive today as it was four decades ago.

This spring, on a gray day with snow still in the woods, my family and I went to the launching of a wooden lobster boat. The boat was sitting in the cradle of a marine railway; the entire assembled community was waiting for high tide; the children were putting pennies on the rails. The owner was happy, the builders were happy, and I was happy that certain things in Maine never change.

<div align="right">

JOHN K. HANSON
Publisher, Maine Boats, Homes & Harbors

</div>

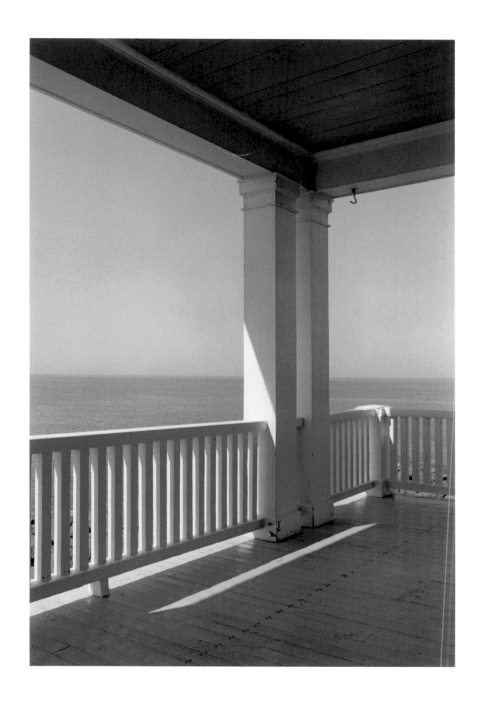

Porch, Monhegan Island, 1971

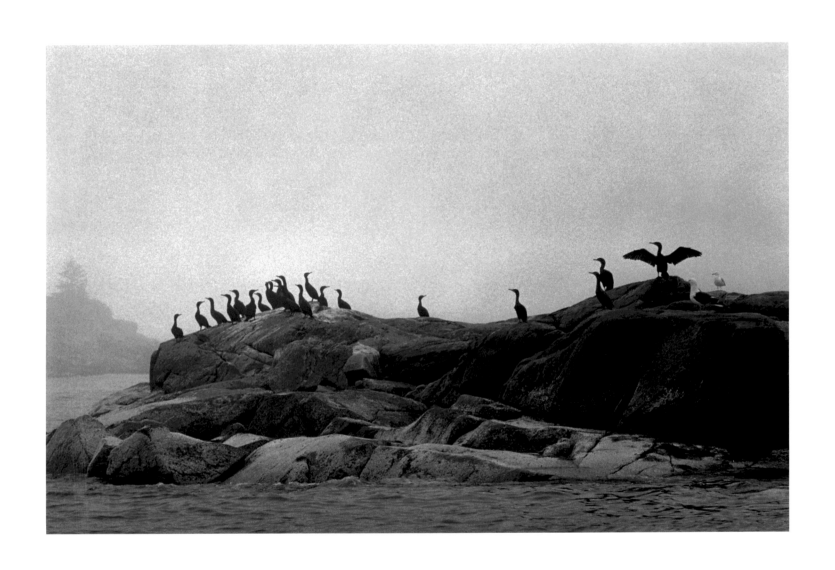

Cormorants off Port Clyde, 1971

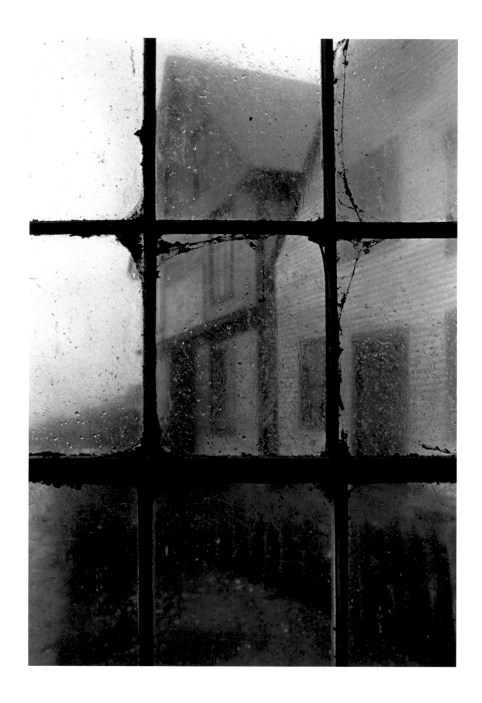

Window, Port Clyde, 1971

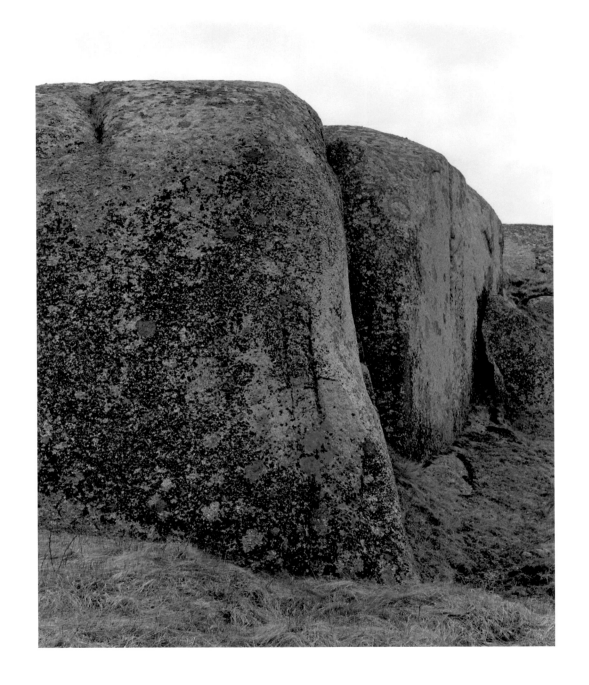

Russ Island, 1971

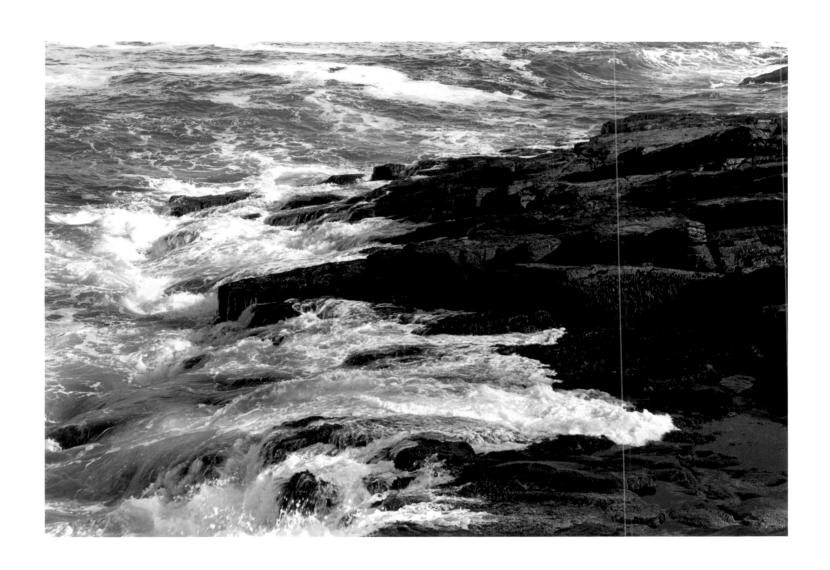

Sea Fringe, Mount Desert Island, 1971

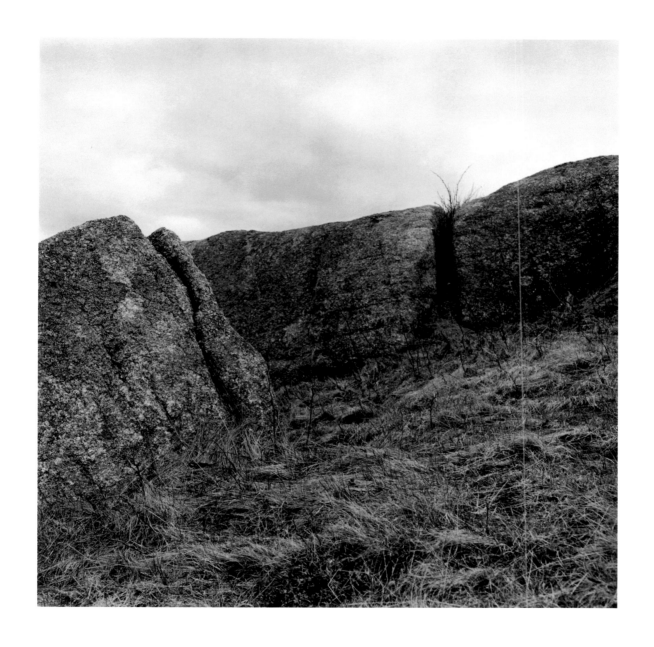

Russ Island, 1971

17

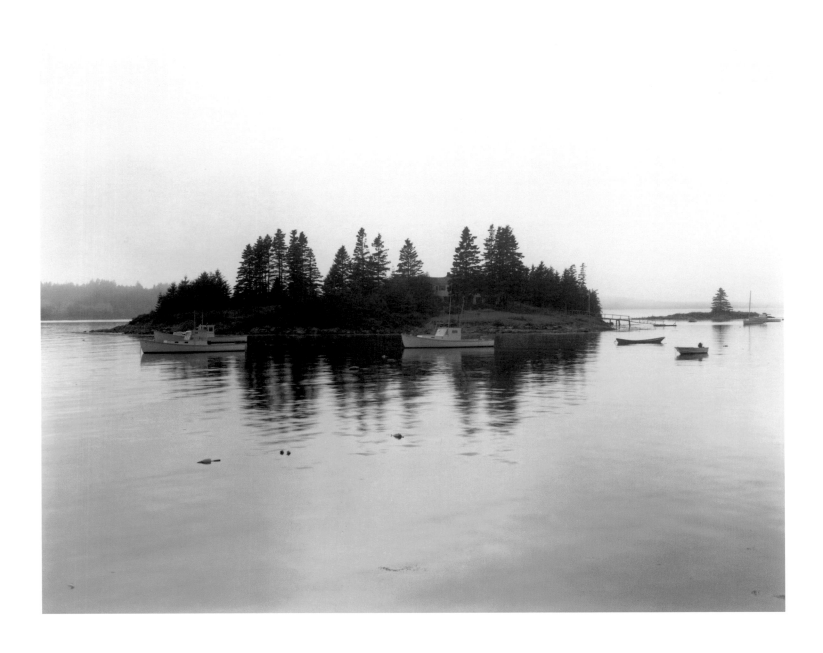

Island off Port Clyde, 1970

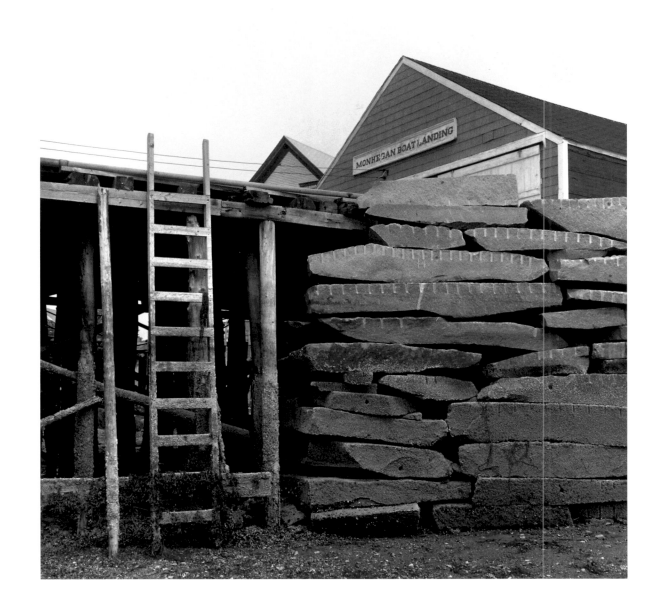

Boat Landing to Monhegan Island, Port Clyde, 1970

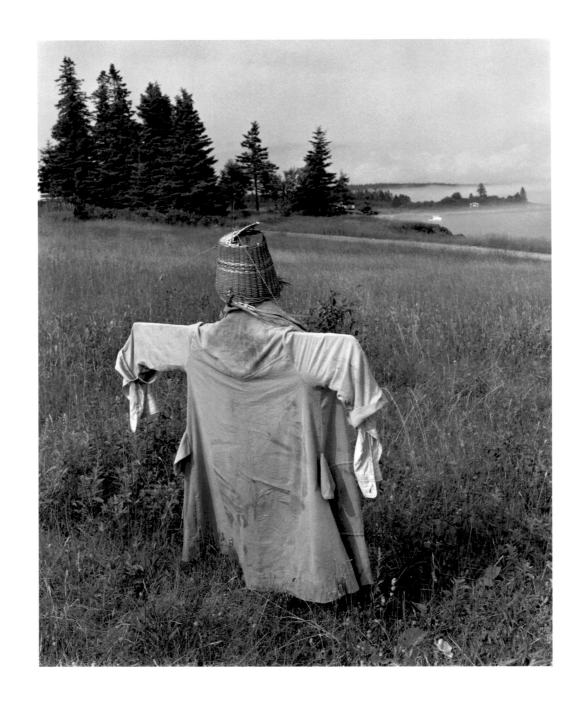

Scarecrow, Starboard, 1971

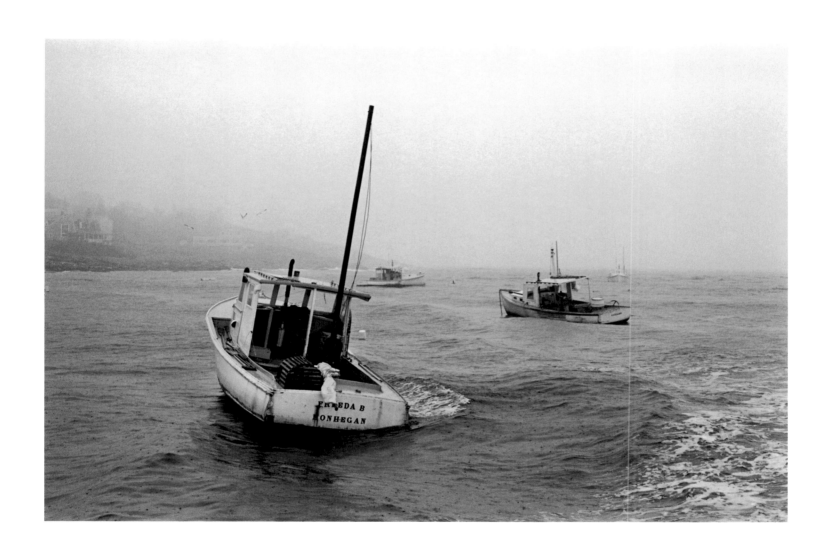

Lobster Boats off Monhegan Island, 1971

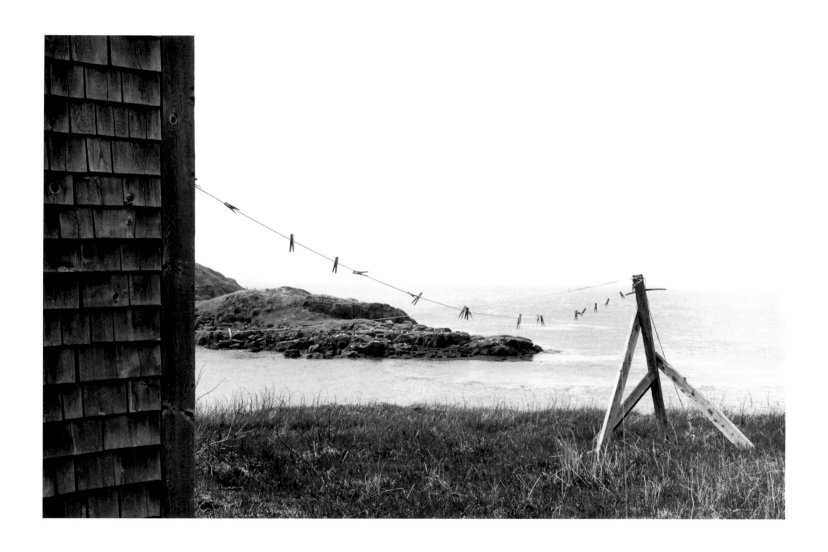

Clothesline, Monhegan Island, 1971

23

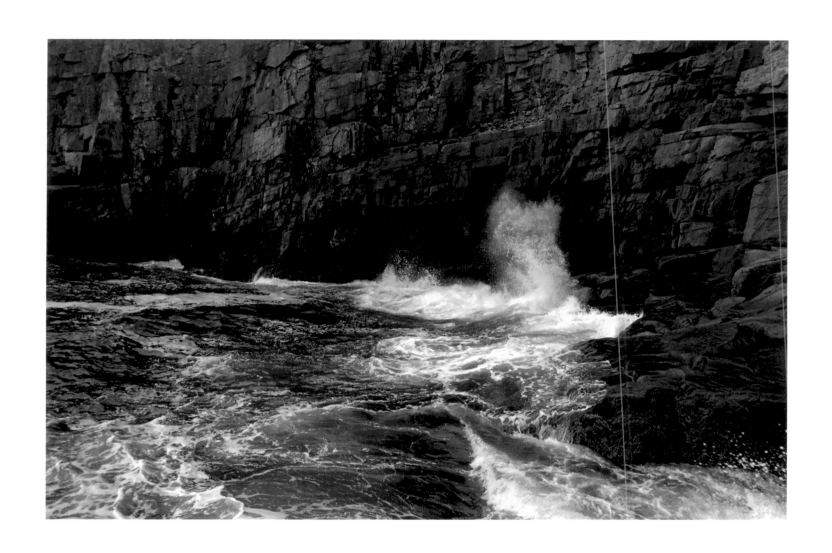

Wave, Mount Desert Island, 1971

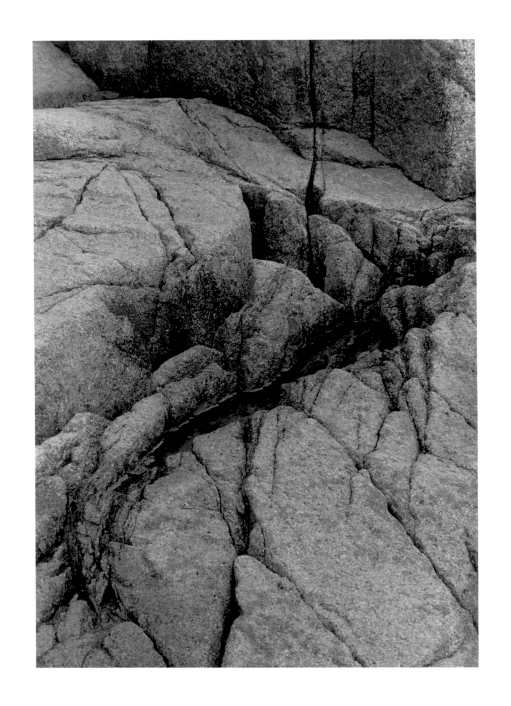

Granite, Mount Desert Island, 1971

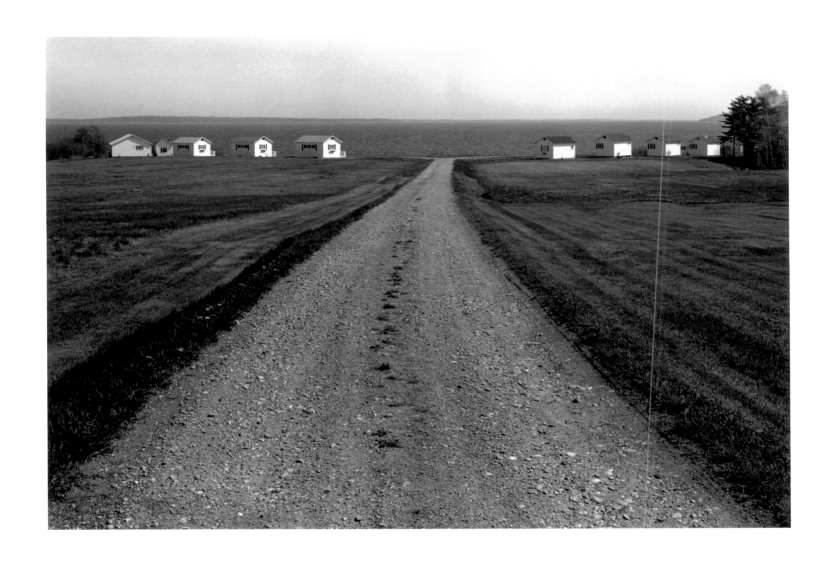

Tourist Cabins, Searsport, 1971

27

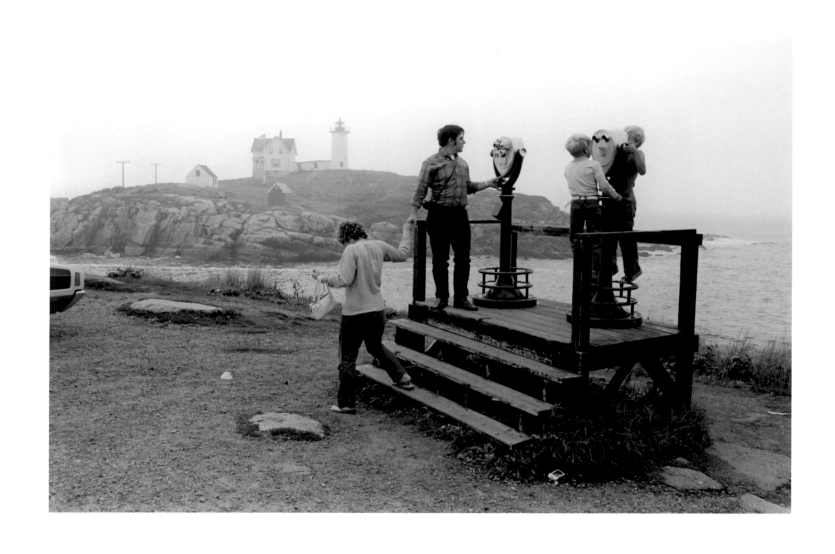

Nubble Light, Cape Neddick, 1971

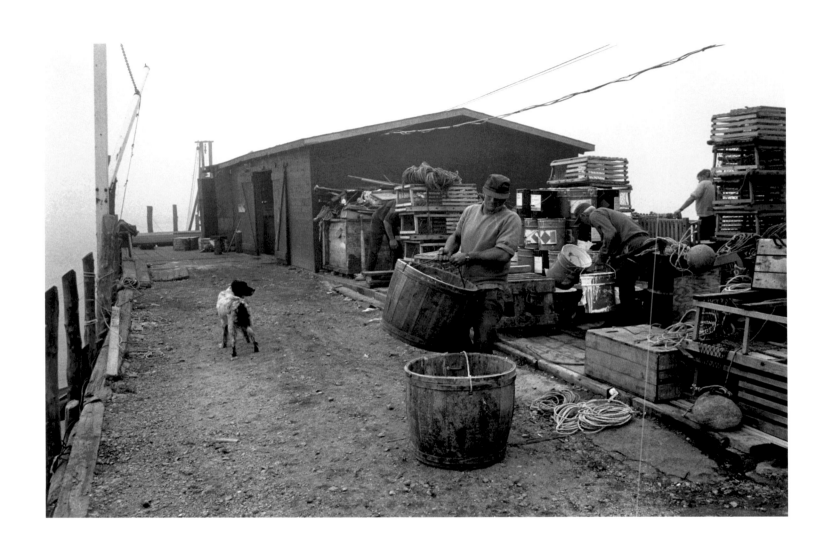

Wharf, Jonesport, 1971

29

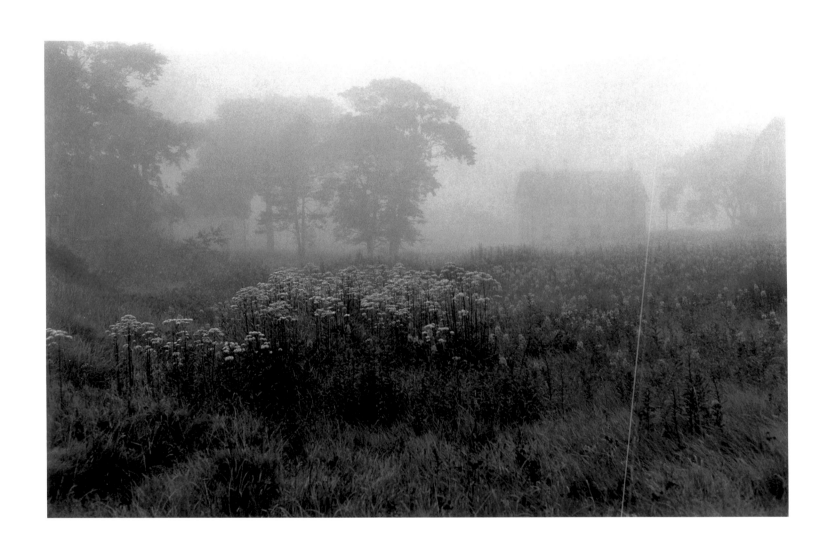

Evening Fog, Jonesport, 1971

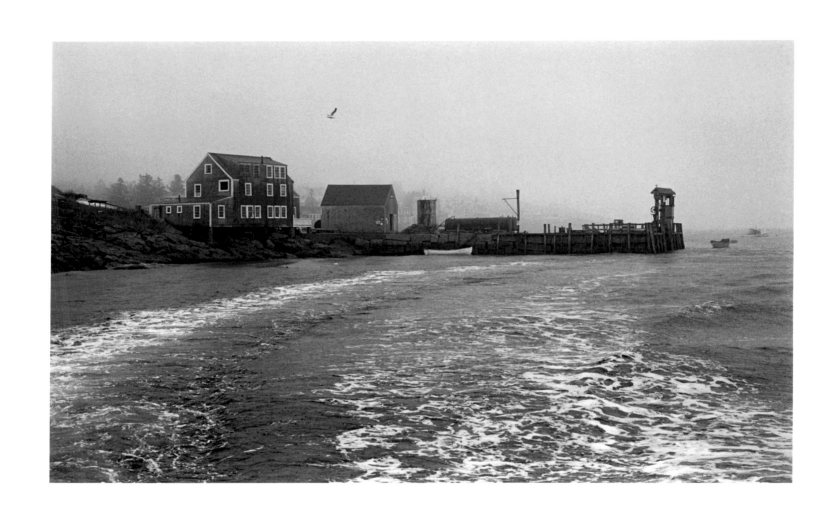

Monhegan Boat Landing, 1971

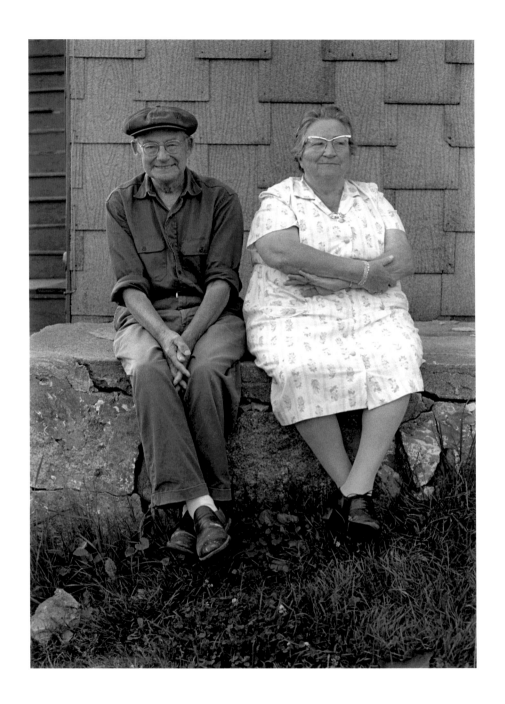

Mr. and Mrs. Alvah Thompson, Port Clyde, 1971

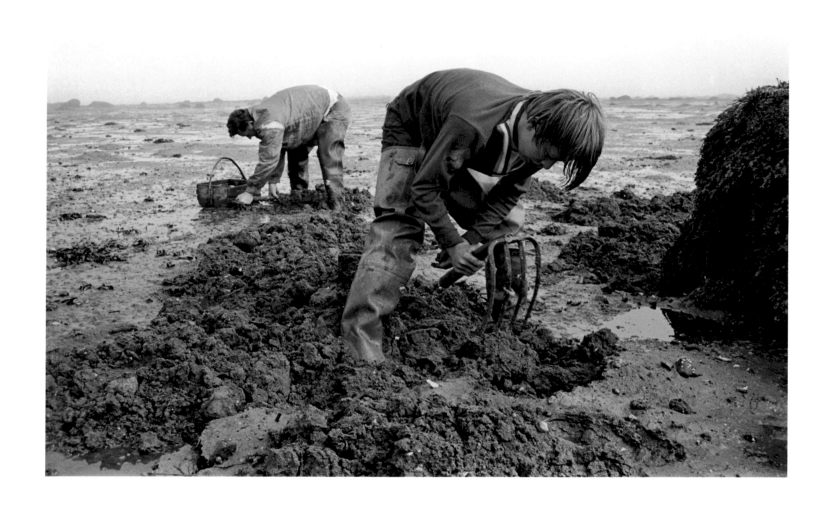

Bertram Peabody and Son Clamdigging, Beals Island, 1971

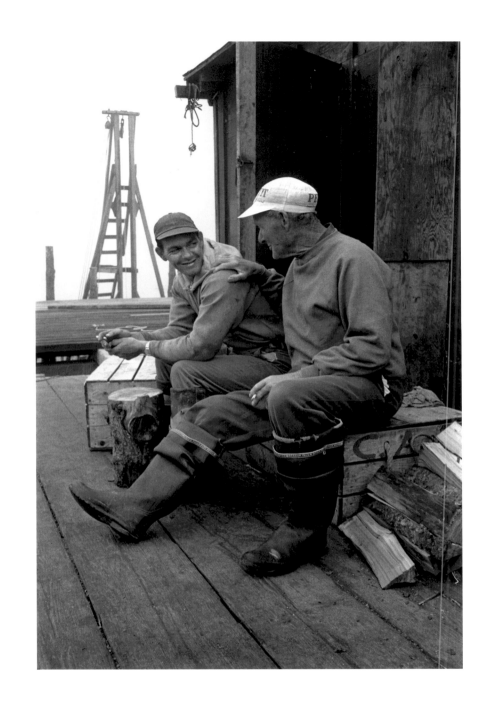

Vernon Woodward and James Polk, Jonesport, 1971

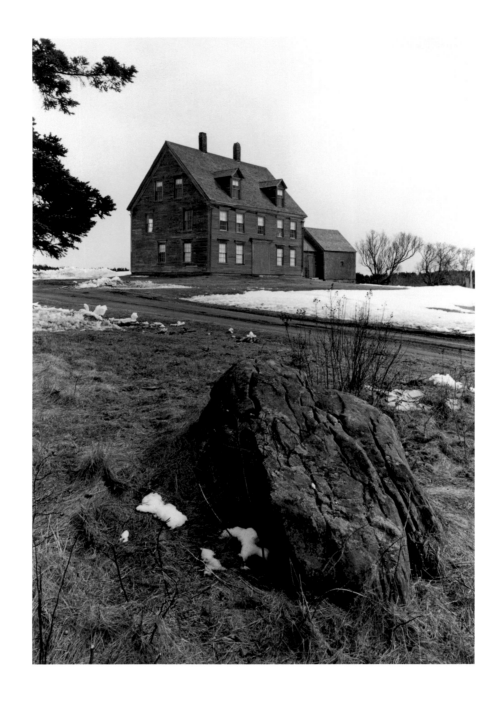

Olsen House, Cushing, 1970

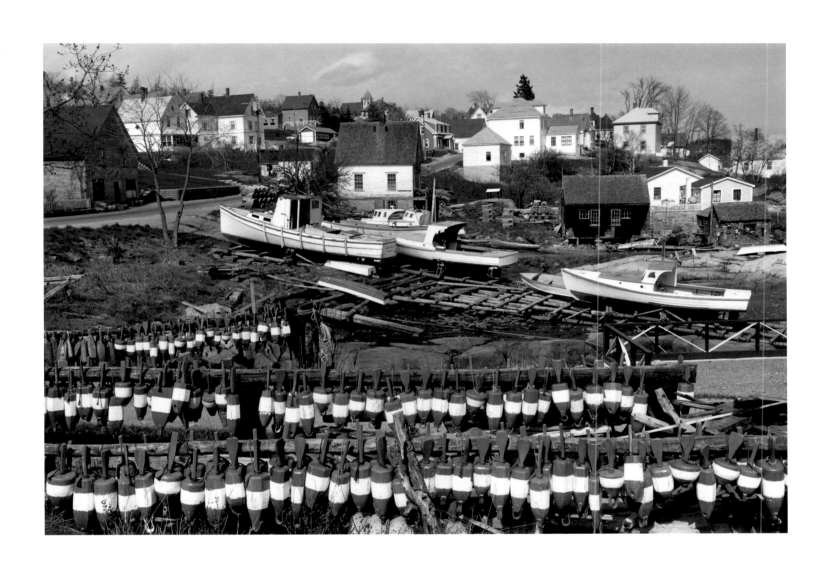

Painted Lobster Buoys, Stonington, 1971

37

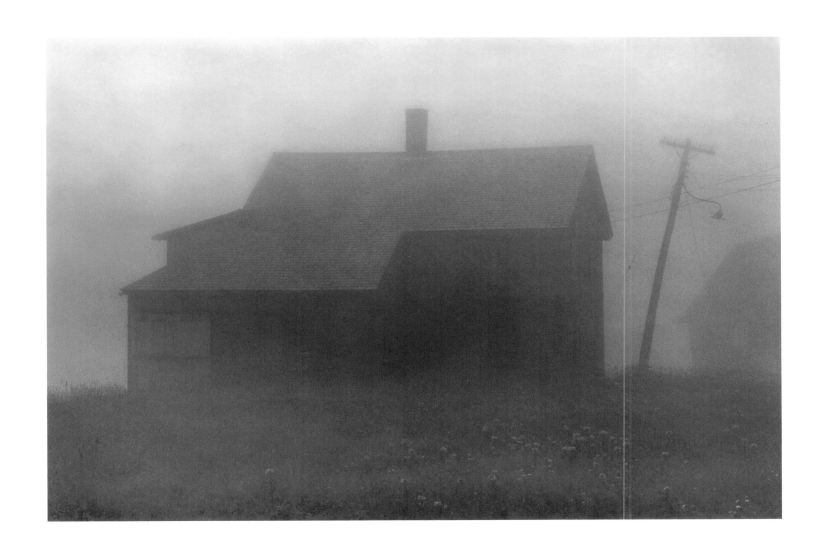

House in Fog, Jonesport, 1971

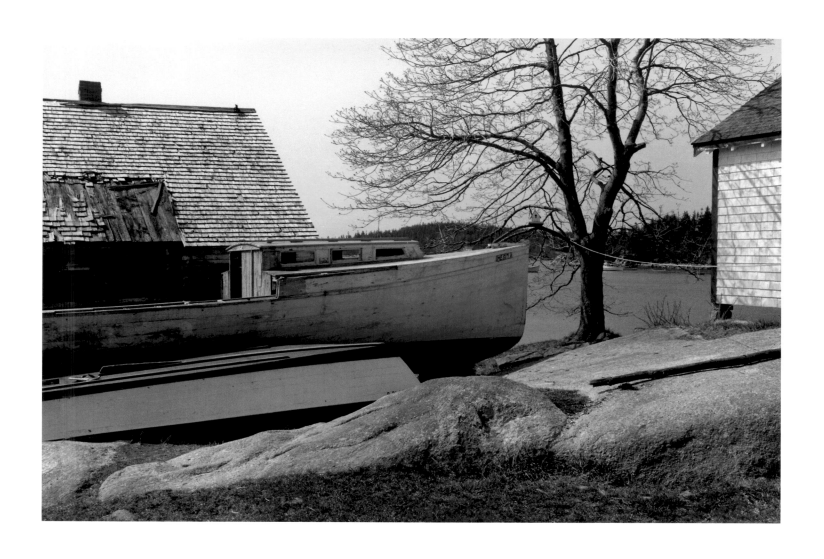

Lobster Boat, Stonington, 1971

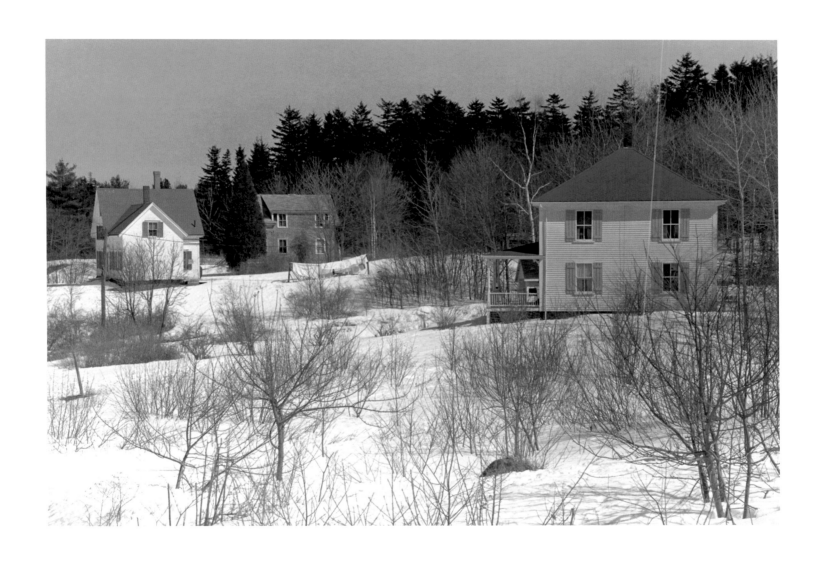

Houses, Southport, 1971

41

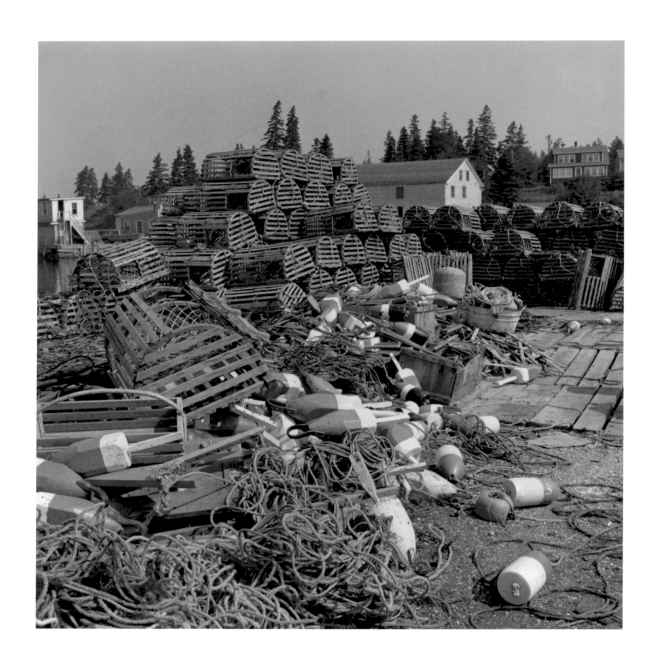

Lobster Traps, Port Clyde, 1970

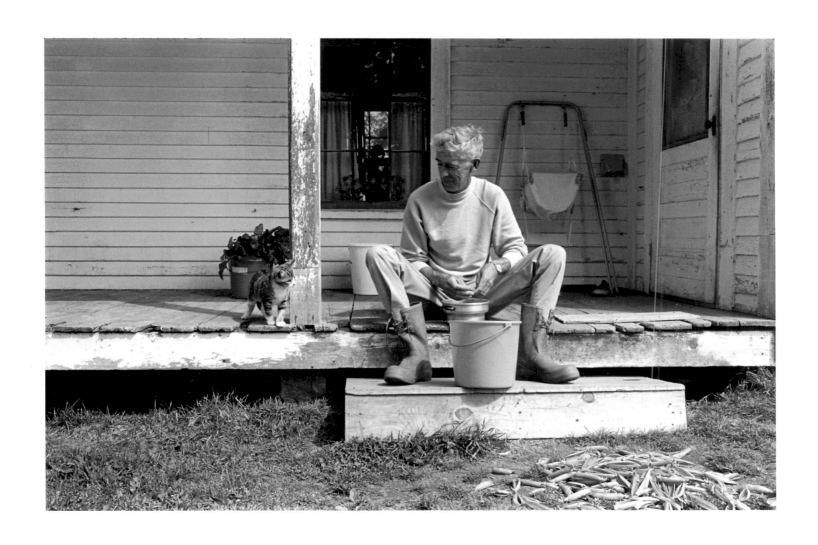

Ralph Brown, Jonesport, 1971

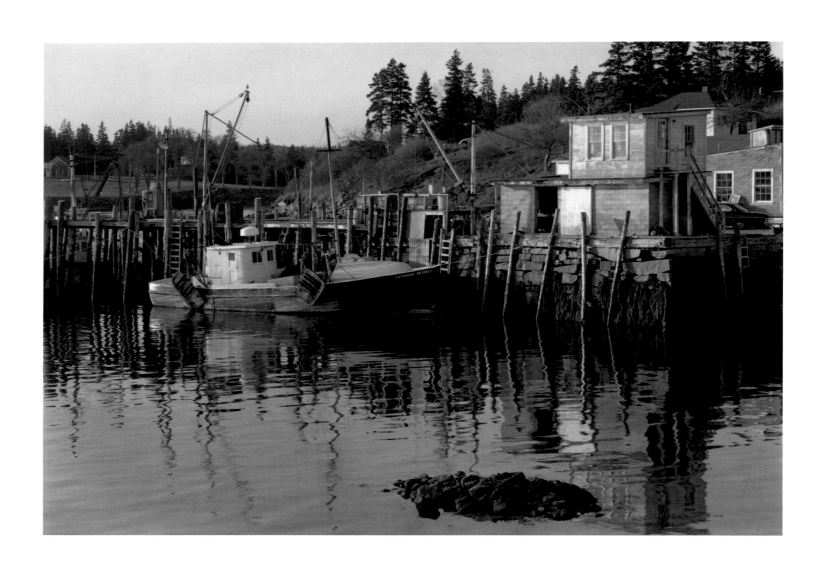

The Catherine-Beverly, Port Clyde, 1971

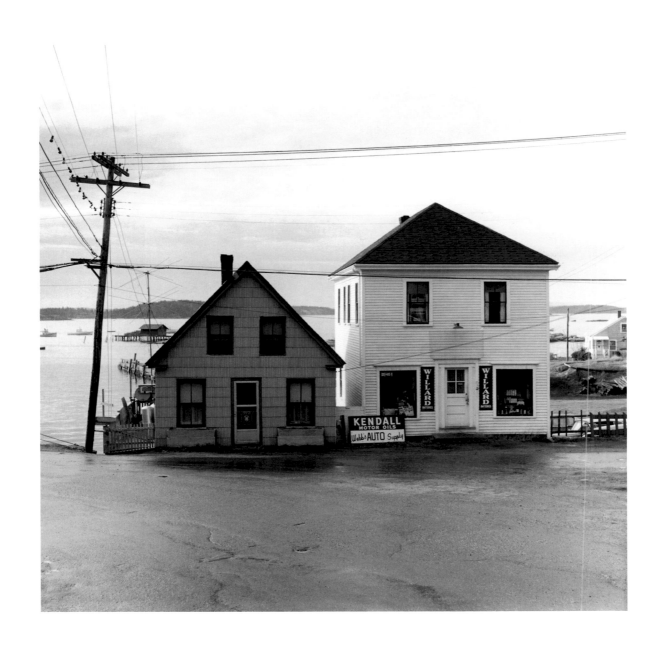

Webb's Auto Supply, Stonington, 1971

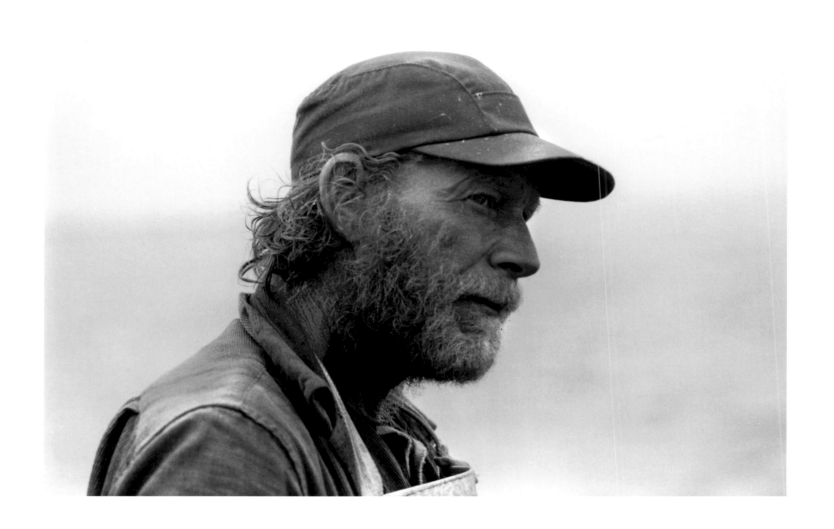

Walt Anderson, Port Clyde, 1971

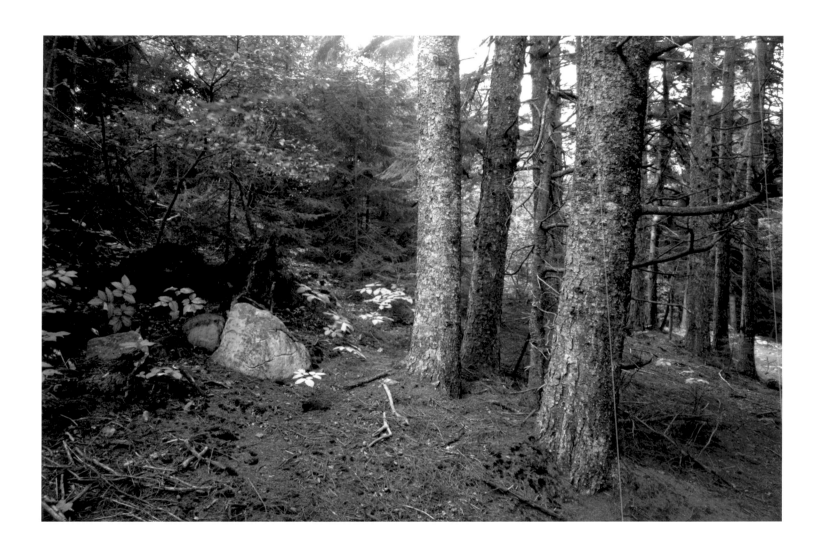

Cathedral Woods, Monhegan Island, 1971

49

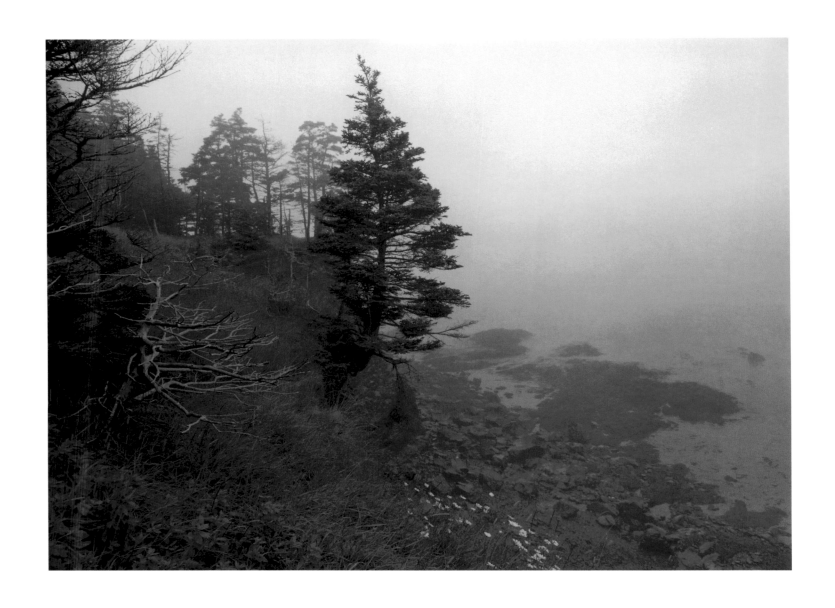

Cliffs, Quoddy Head, 1971

Lionel Barbour, Stonington, 1971

51

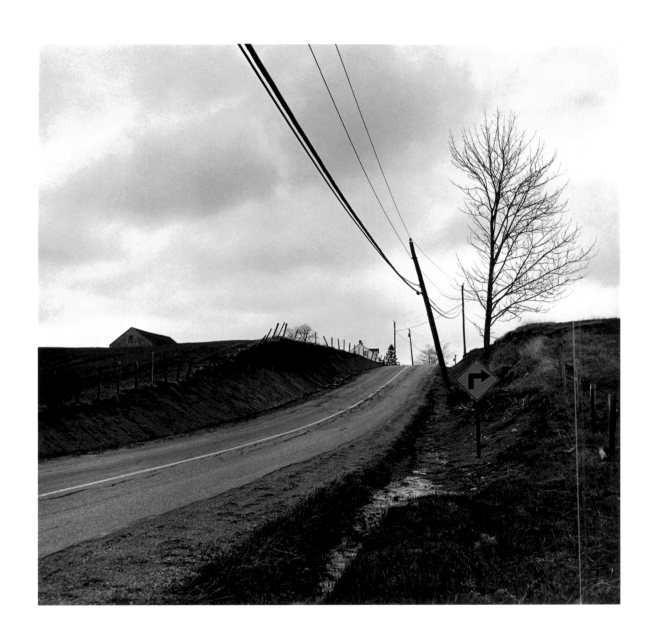

Road to Deer Isle, 1971

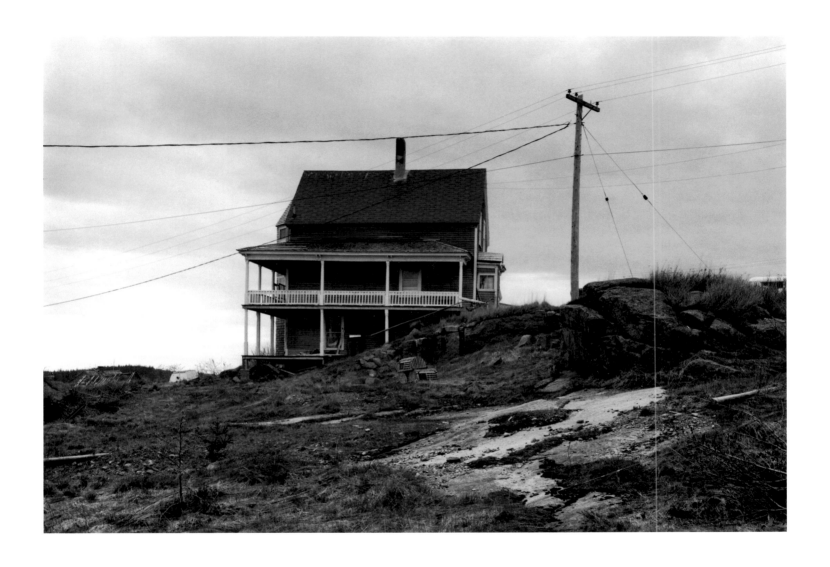

House by the Sea, Stonington, 1971

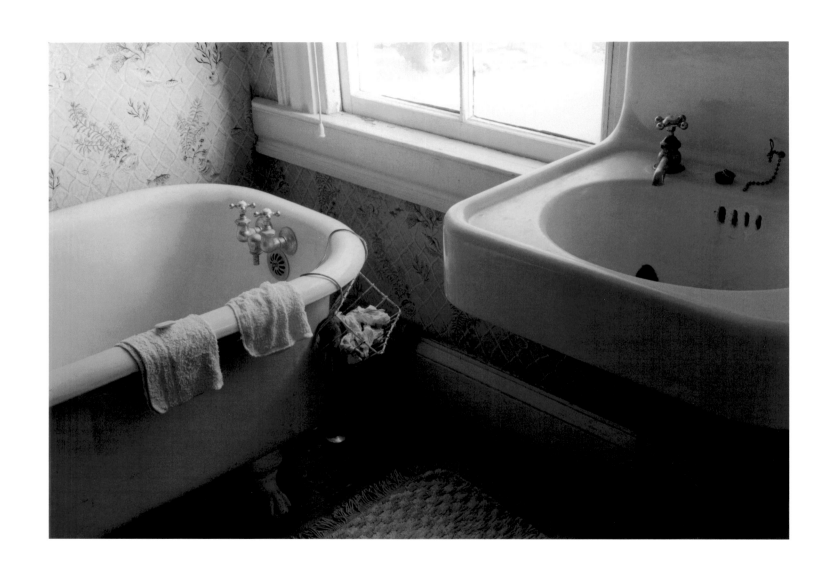

Bathroom, Alma Heal's Hotel, Port Clyde, 1971

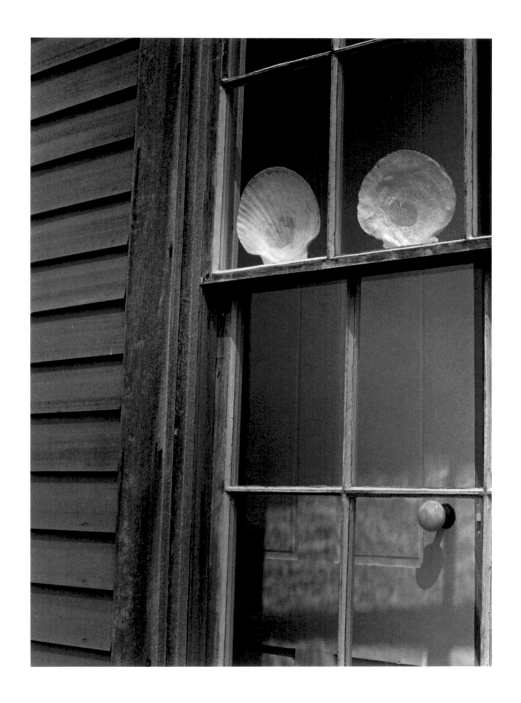

Window, Olsen House, Cushing, 1970

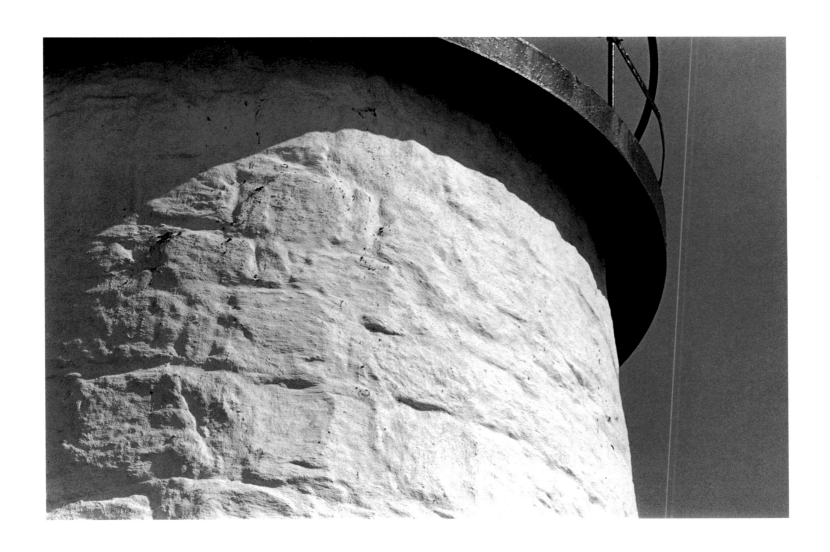

Pemaquid Light, Pemaquid Point, 1970

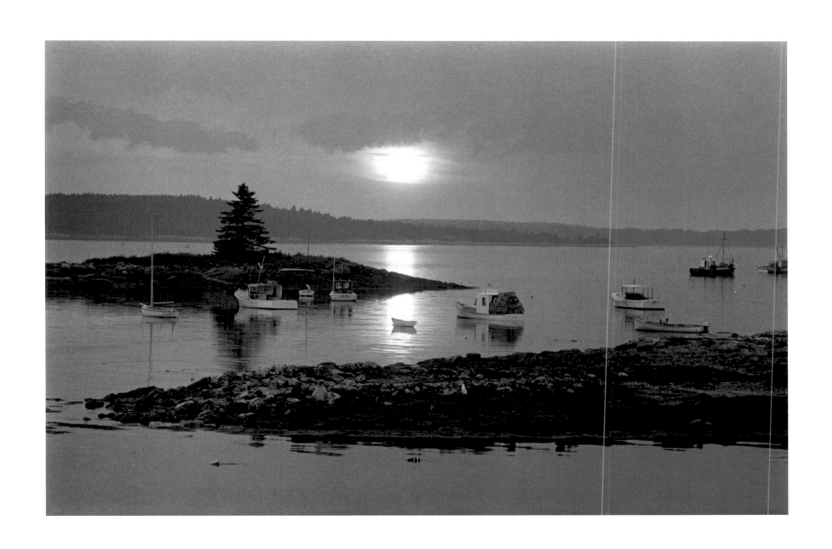

Port Clyde at Sunset, 1971

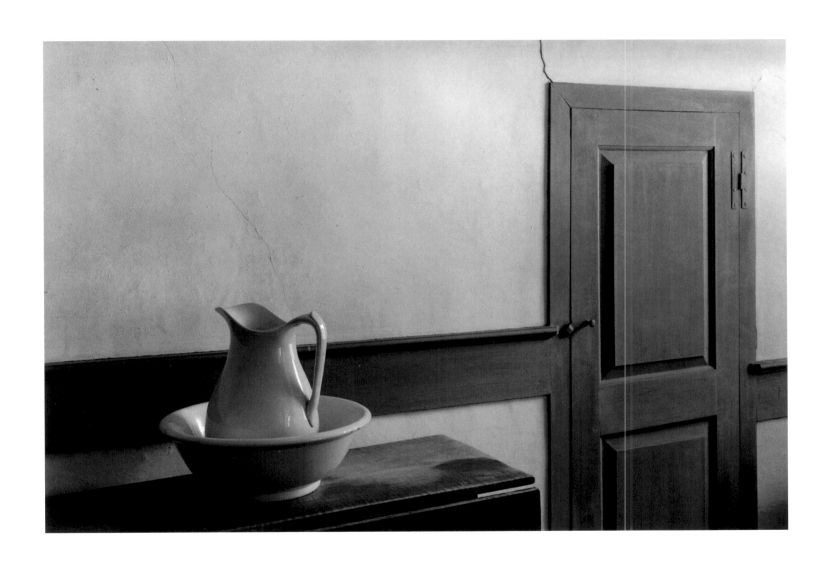

Shaker Interior, Sabbathday Lake, 1971

63

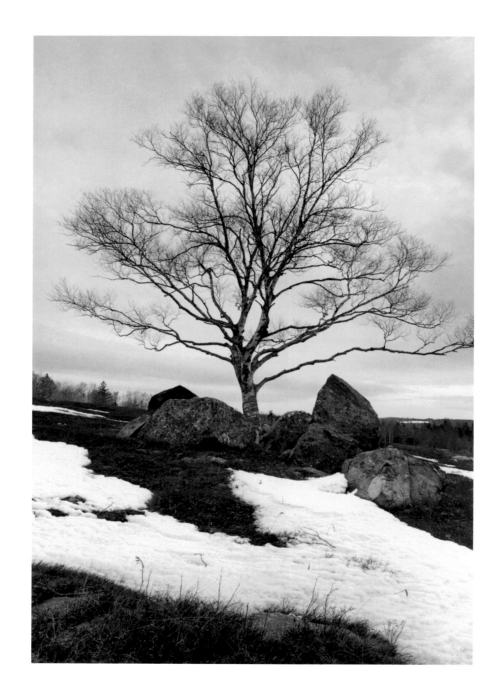

Encircled Tree, Sargenty, 1971

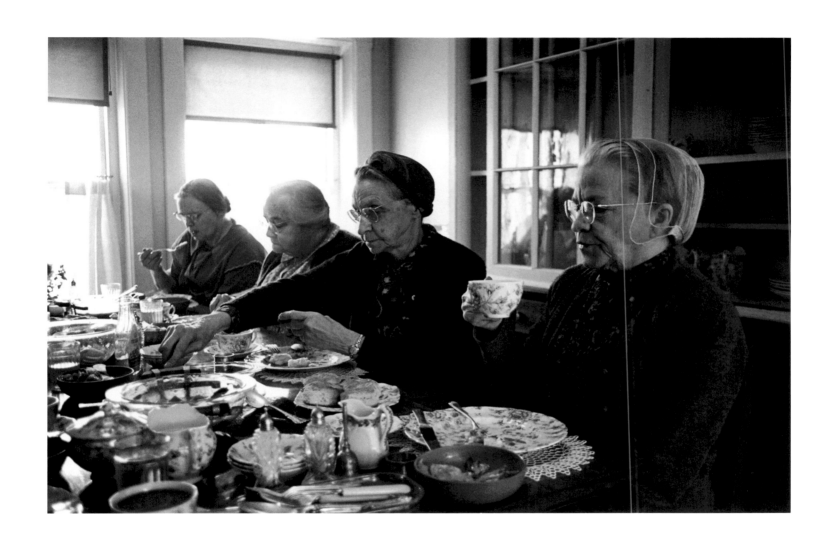

Shakers at Dinner, Sabbathday Lake, 1971

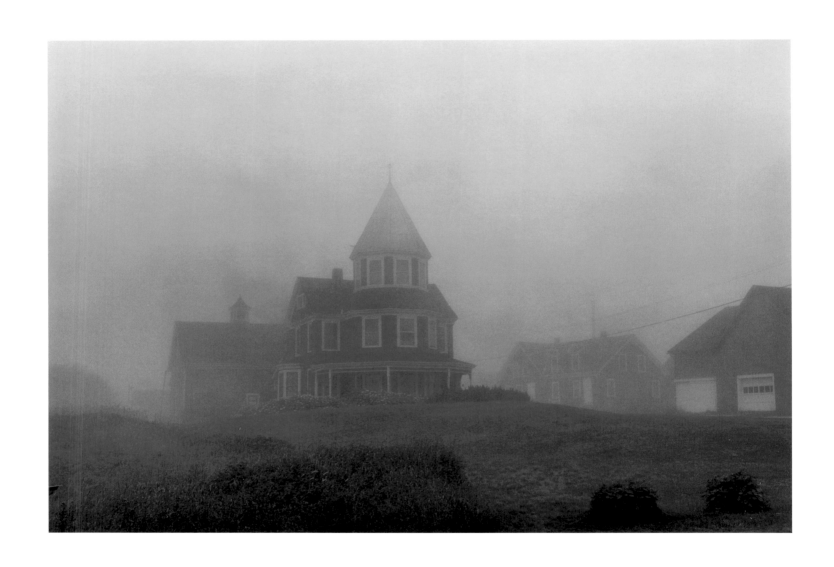

Morning Fog, Jonesport, 1971

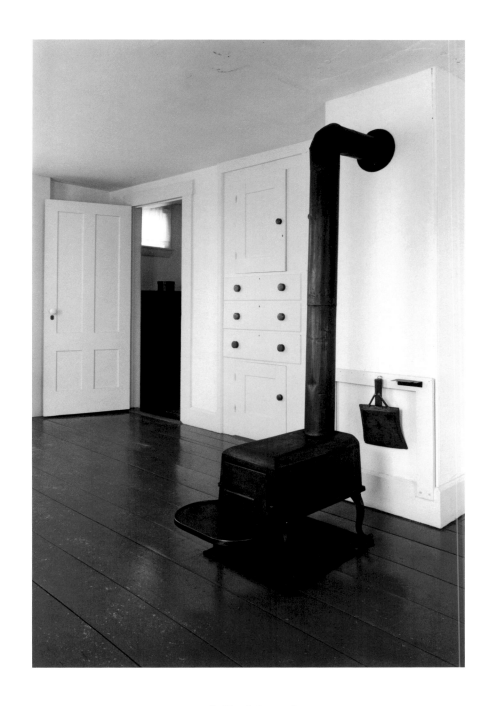

Interior, Sabbathday Lake, 1971

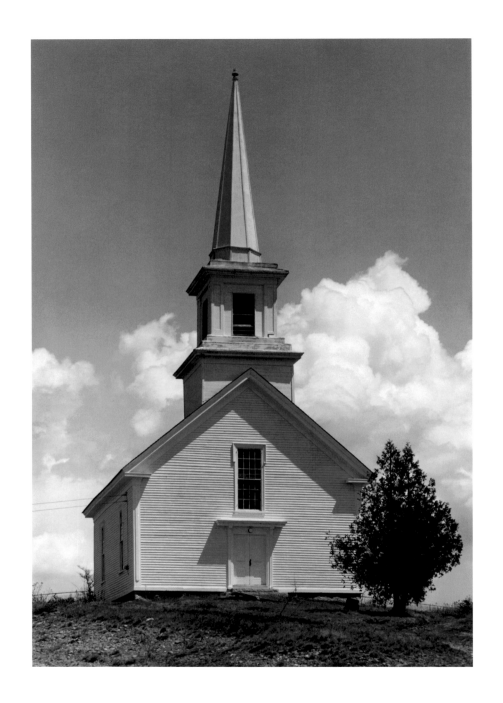

White Church, Stonington, 1971

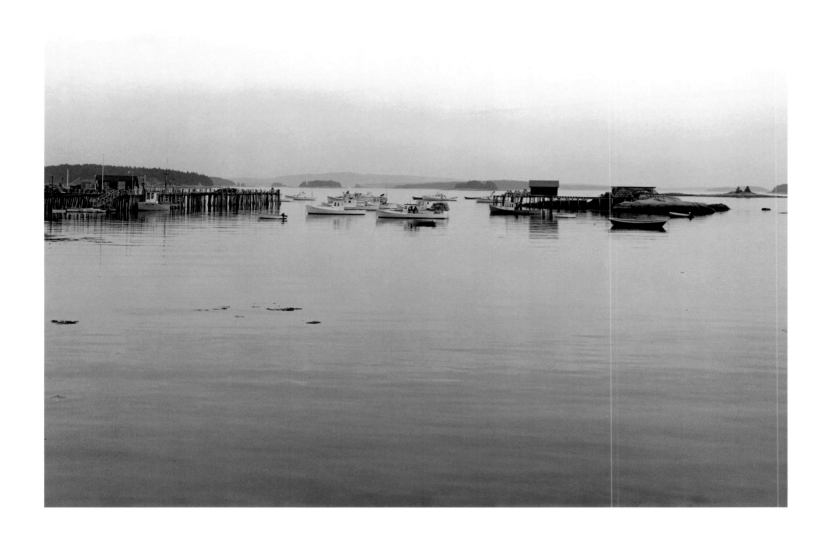

Stonington Harbor, 1971

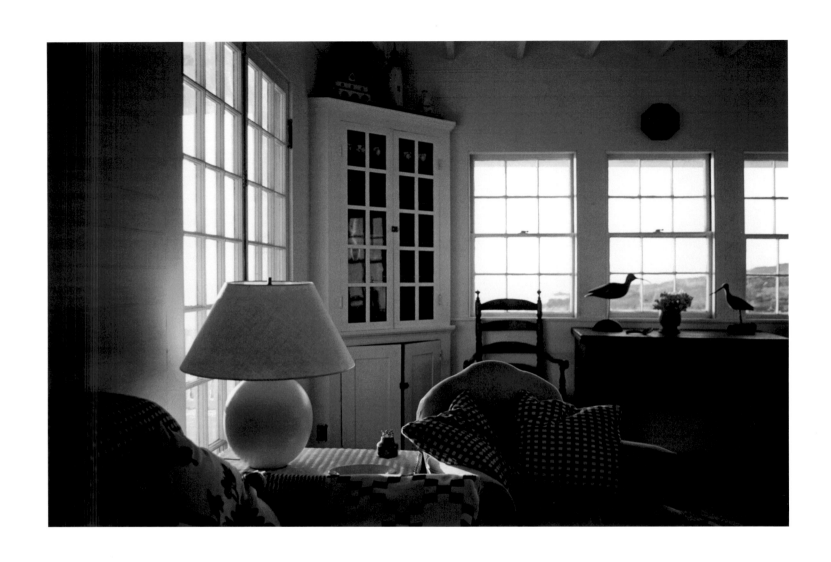

Interior, Monhegan Island, 1971

70

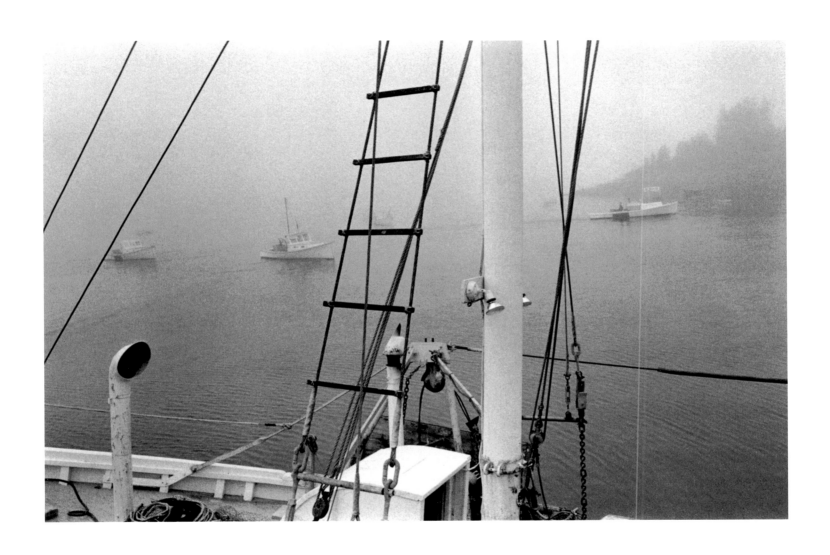

Fishing Boat in Fog, Port Clyde, 1970

71

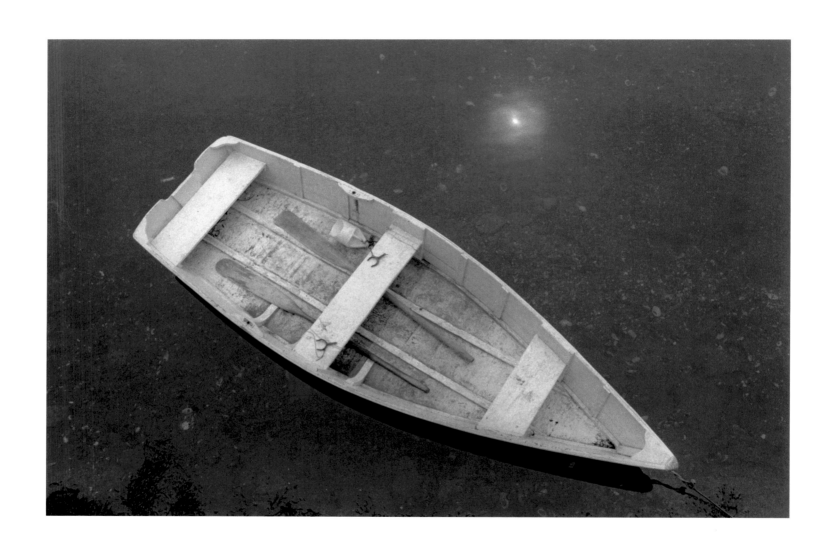

Rowboat, Port Clyde, 1970

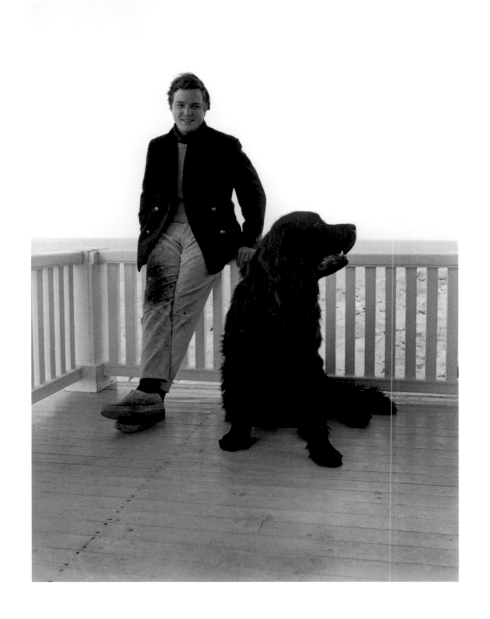

Jamie Wyeth, Monhegan Island, 1971

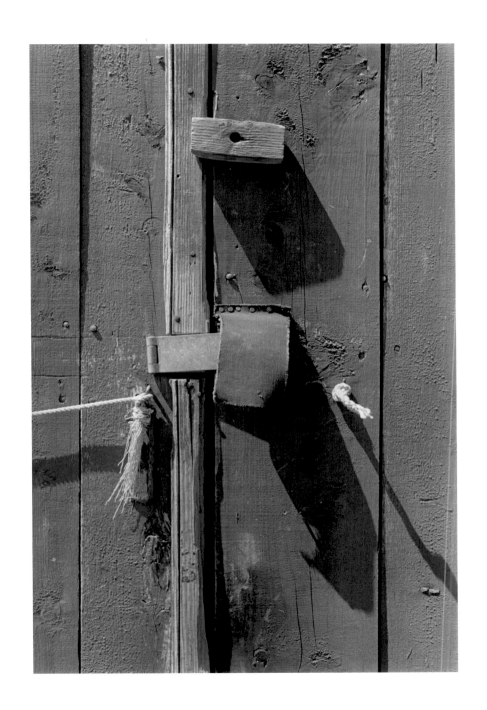

Boatyard Detail, Thomaston, 1971

75

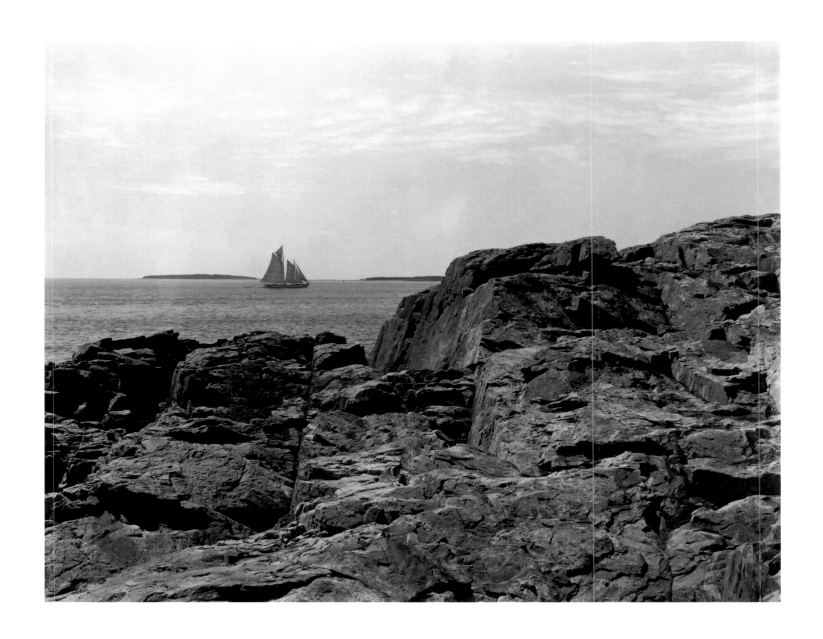

Schooner off Mount Desert Island, 1970

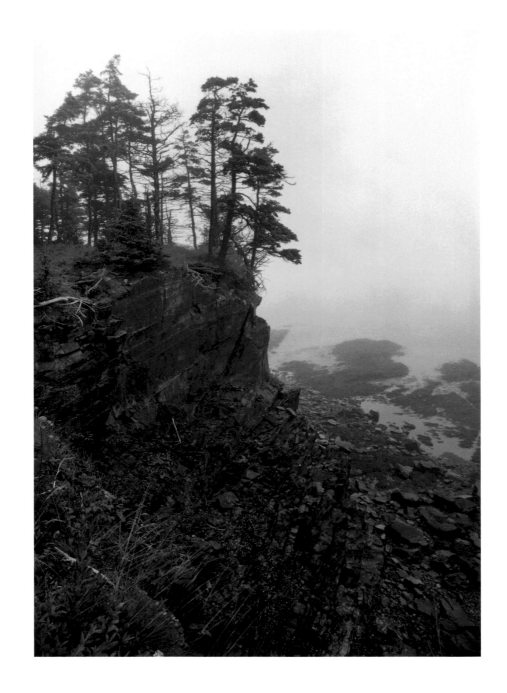

Cliffs, Quoddy Head, 1971

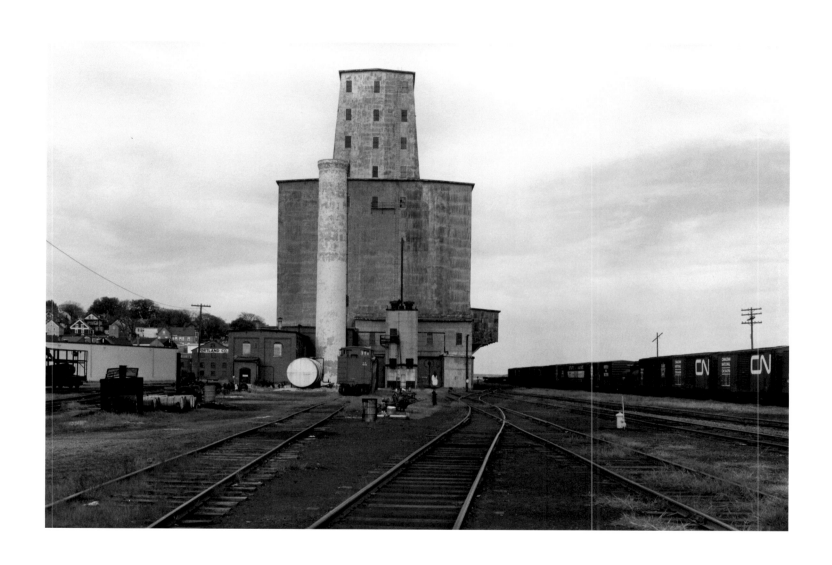

Grain Elevator, Portland, 1971

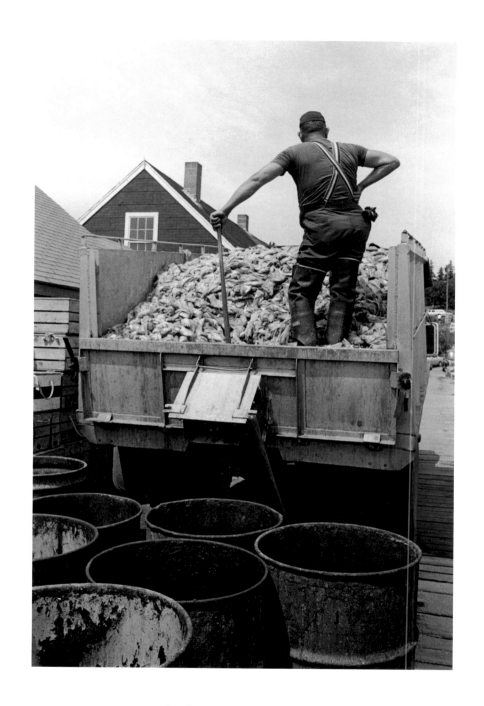

Unloading Bait, Friendship, 1971

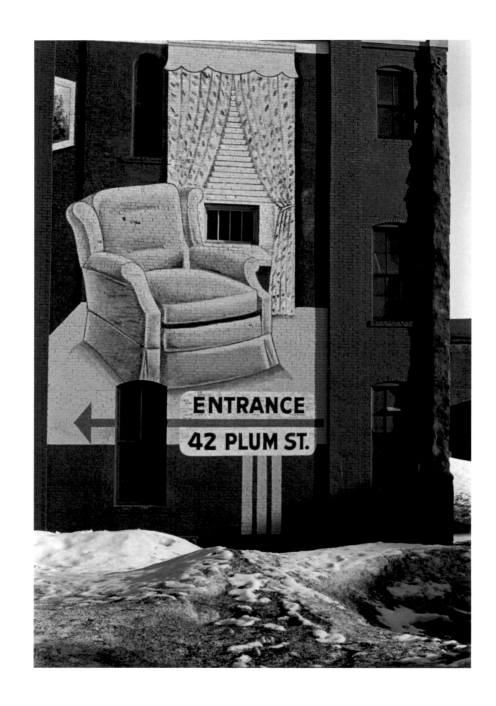

Young's Furniture Store, Portland, 1971

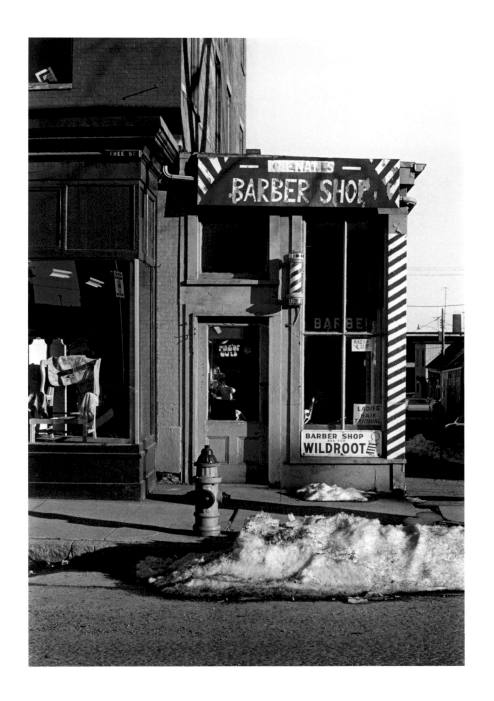

Keenan's Barber Shop, Portland, 1971

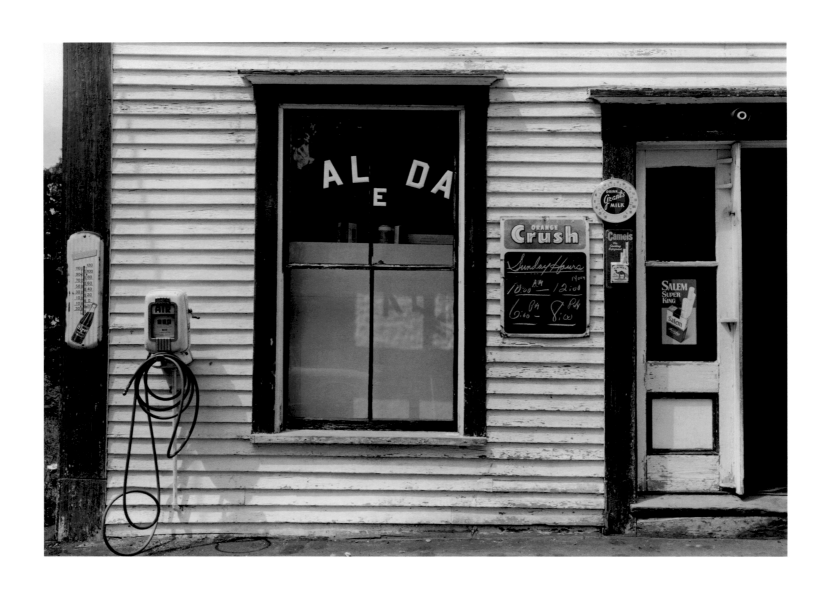

Wallace Market, Friendship, 1971

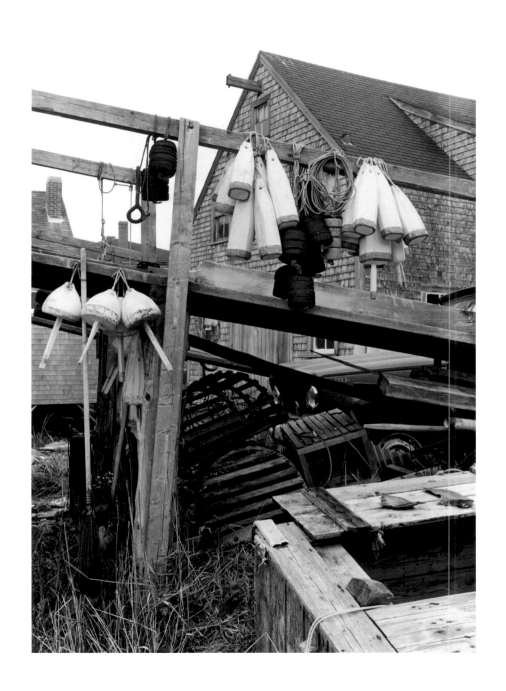

Lobster Pots and Buoys, Monhegan Island, 1971

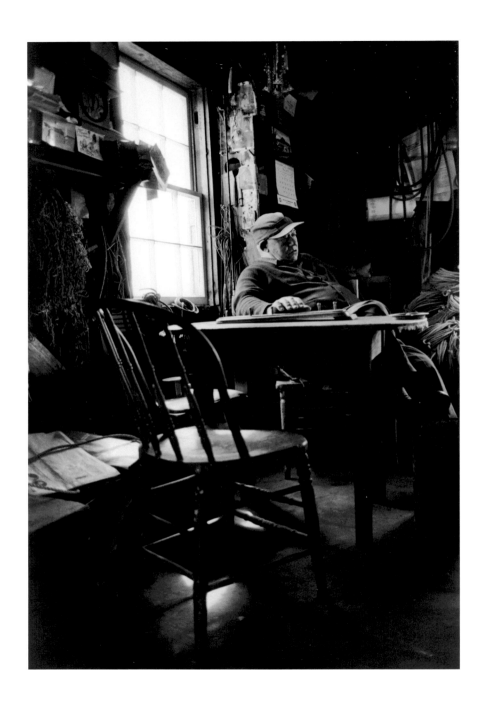

Dwight Stanley, Monhegan Island, 1971

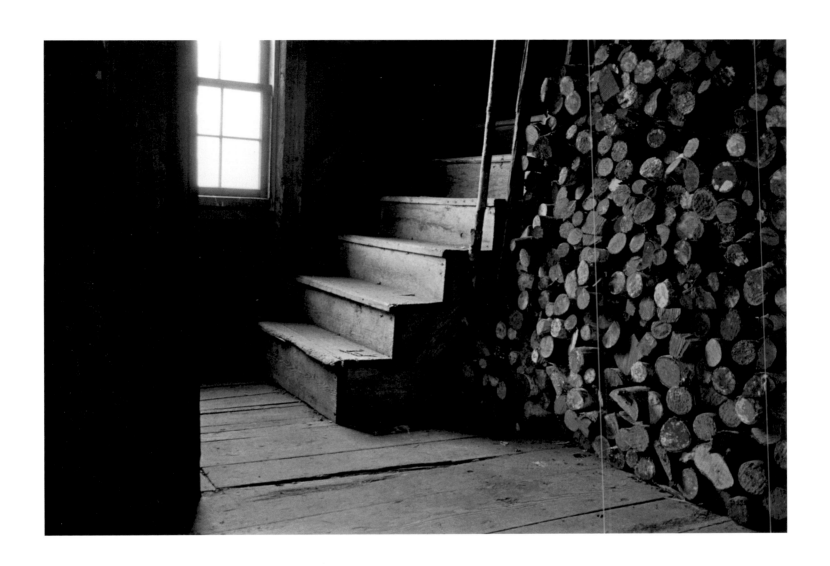

Interior, Olsen House, Cushing, 1971

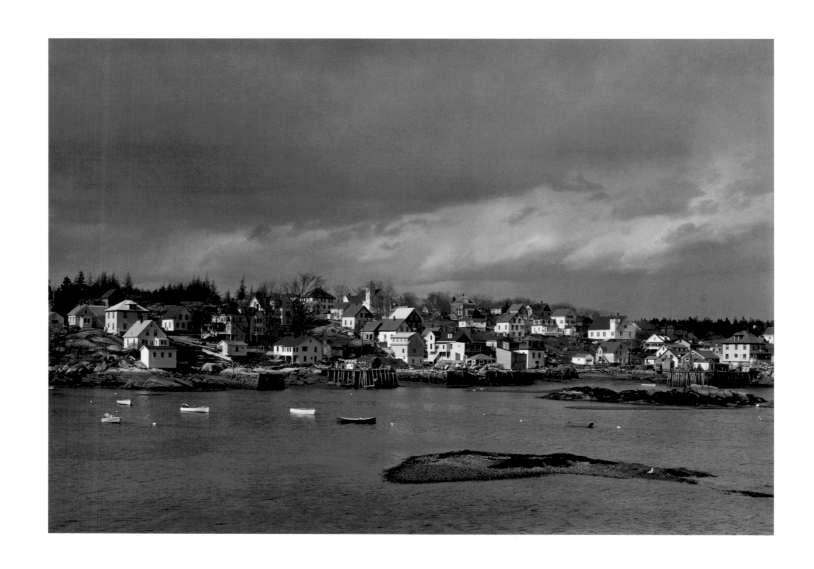

View of Stonington, 1971

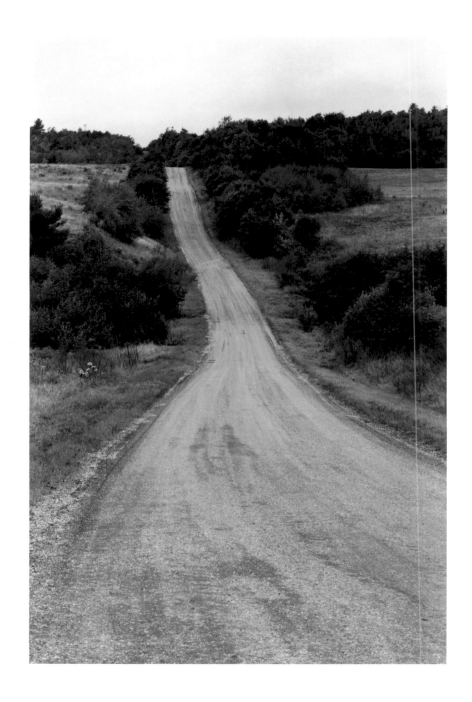

Road, Edgecomb, 1971

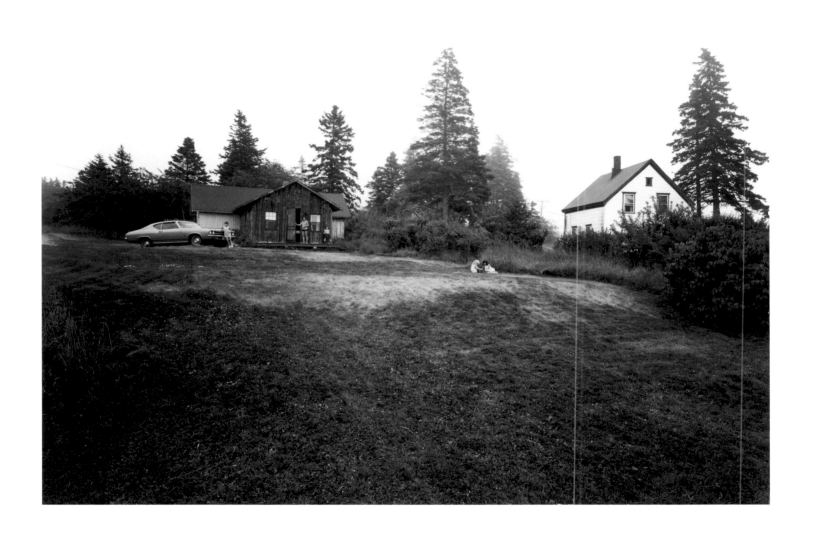

Tourist Cabin, Port Clyde, 1970

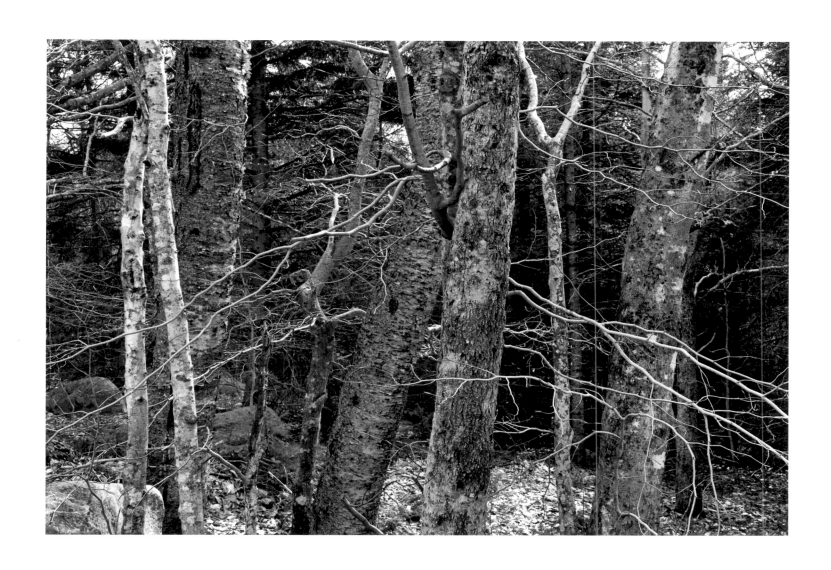

Woods, Stonington, 1971

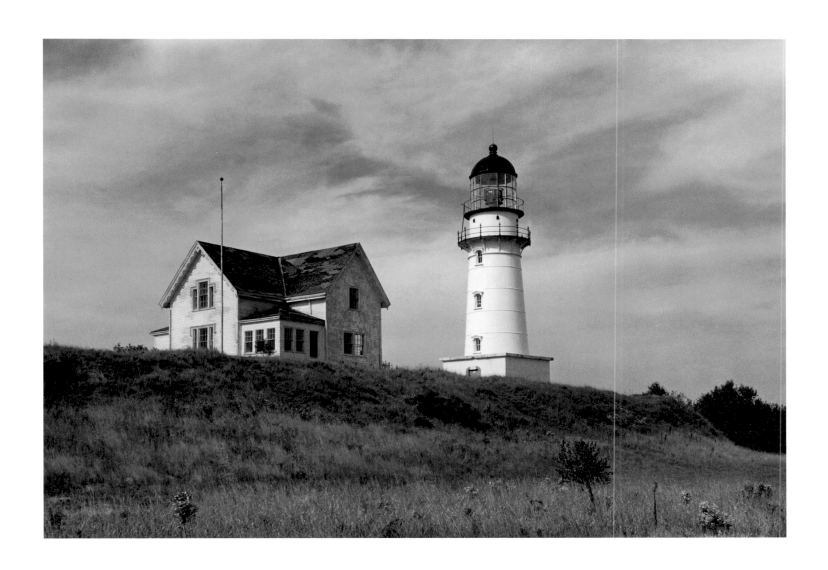

Two Lights, Cape Elizabeth, 1971

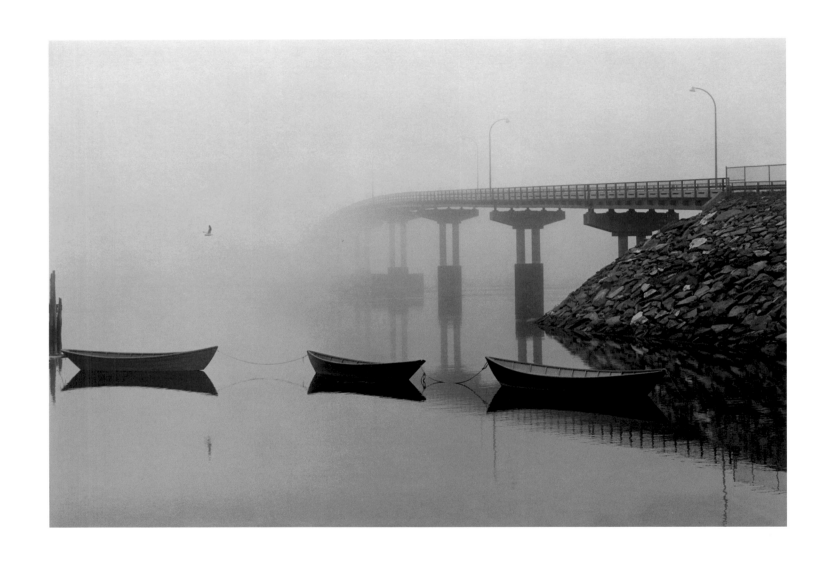

International Bridge to Campobello Island, Lubec, 1971

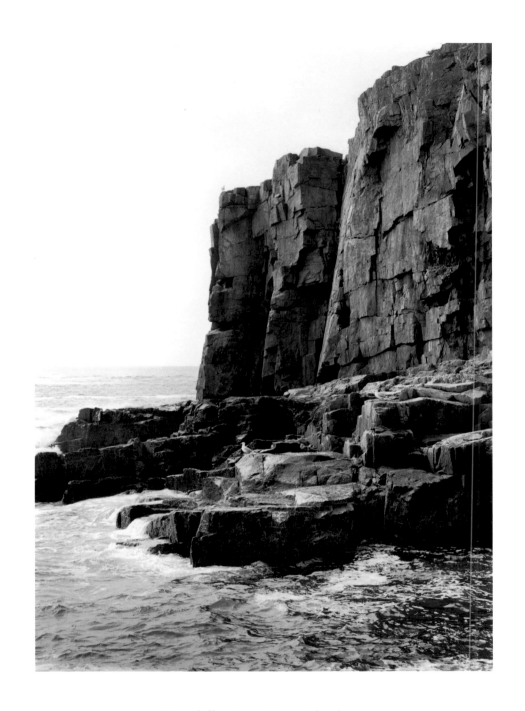

Otter Cliffs, Mount Desert Island, 1971

97

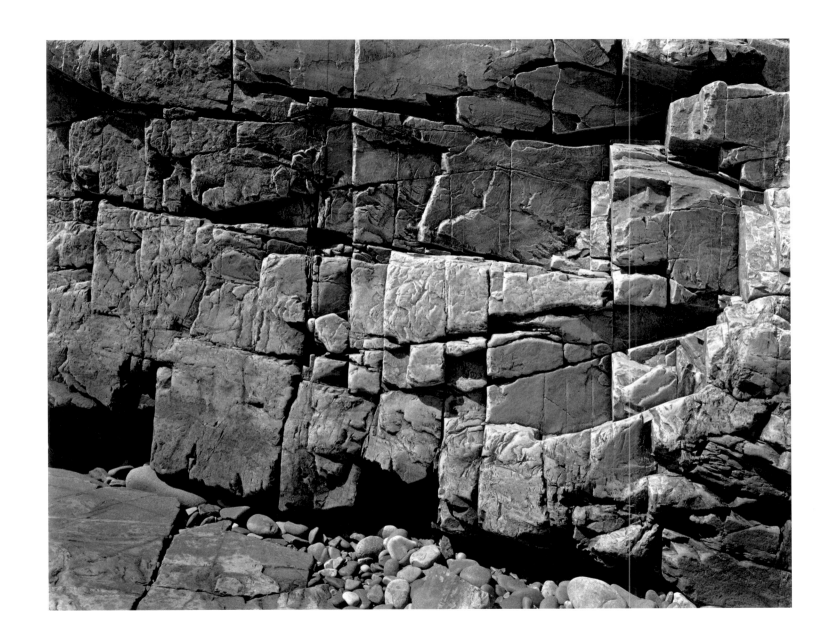

Rock Wall, Mount Desert Island, 1970

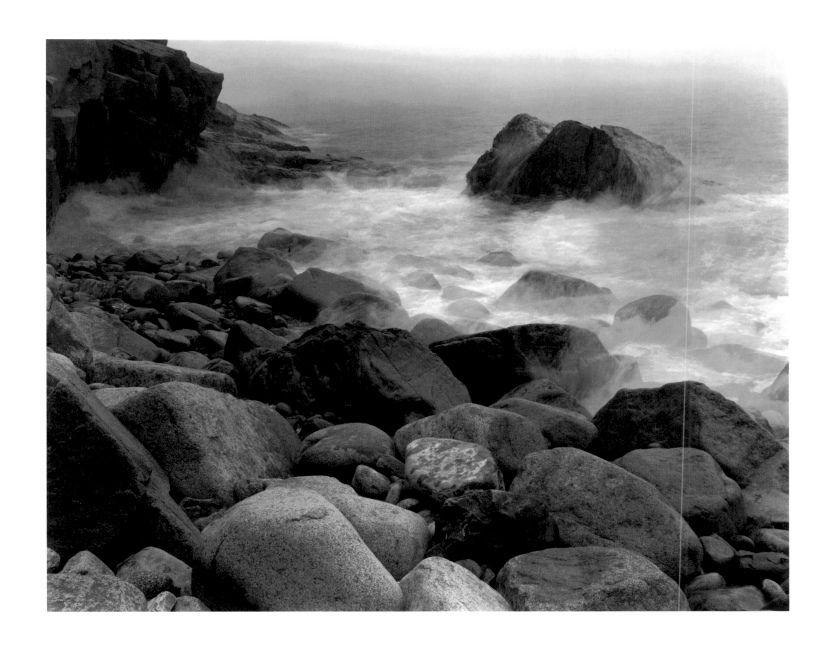

Mount Desert Island, 1970

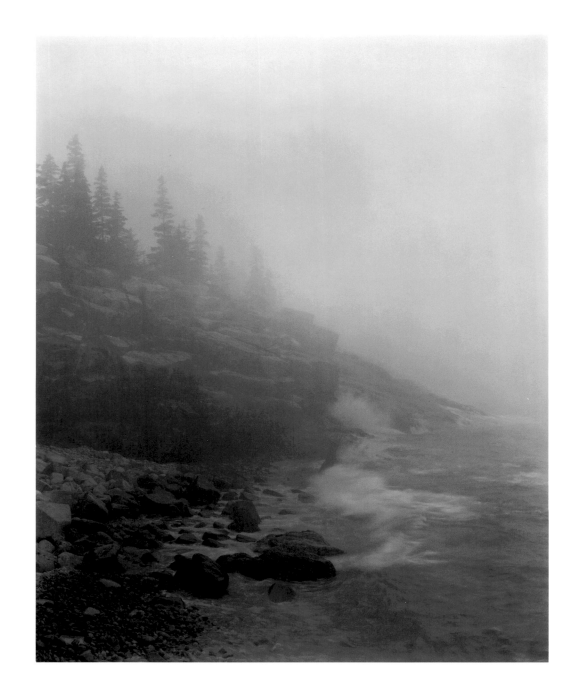

Shore in Fog, Mount Desert Island, 1970

102

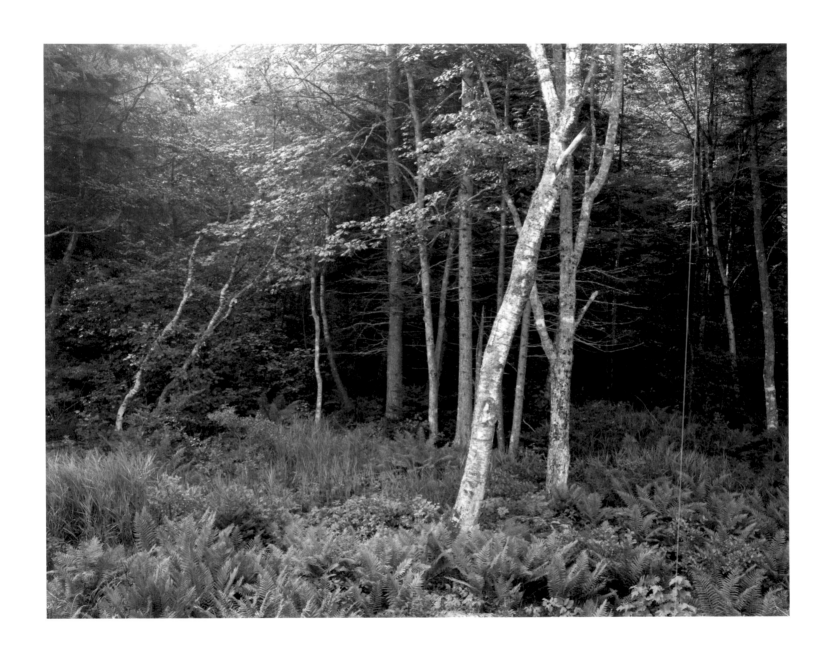

Woods, Port Clyde, 1970

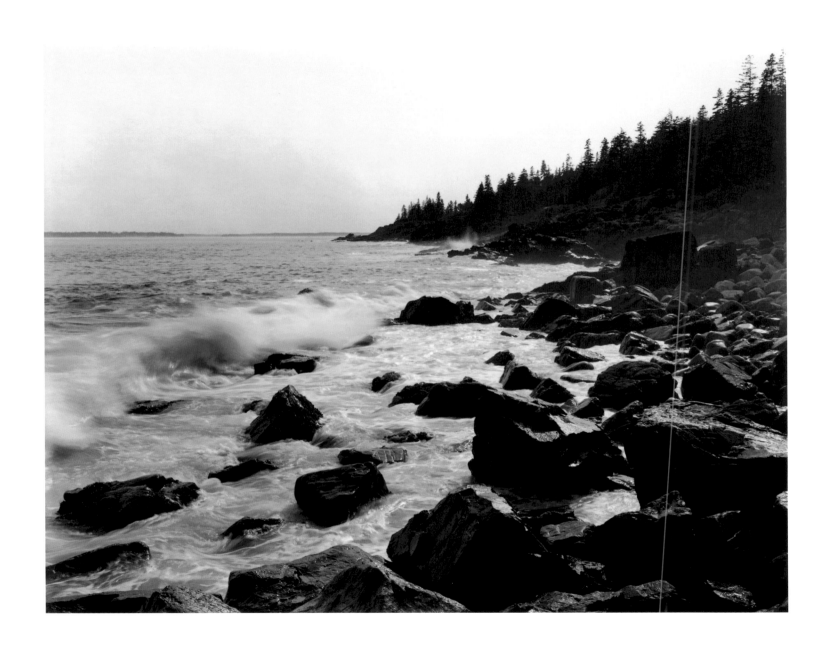

Mount Desert Island, 1970

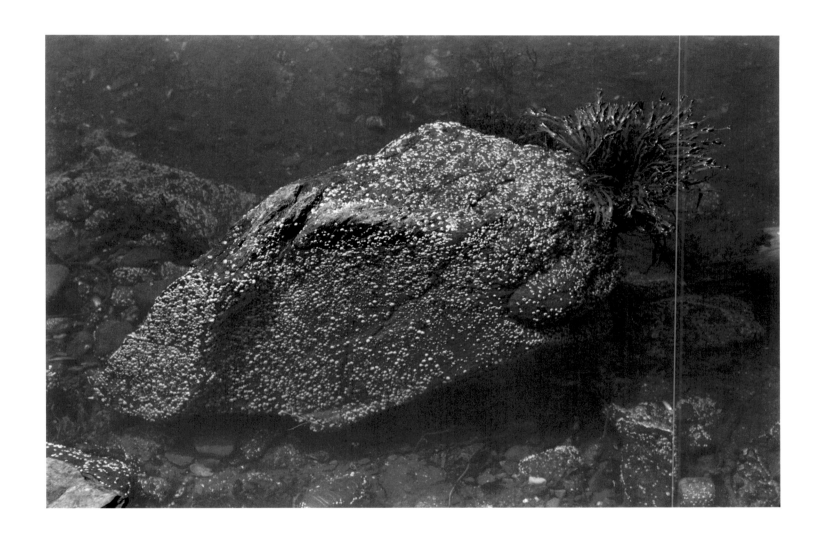

Submerged Rock, Port Clyde, 1978

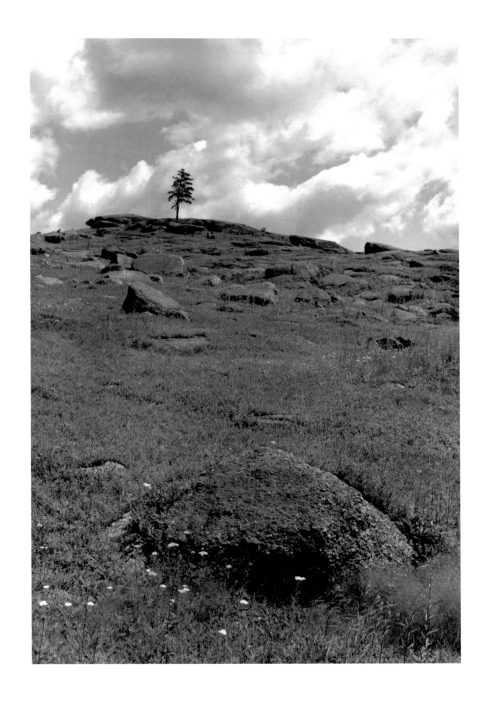

Lone Tree, Orland, 1981

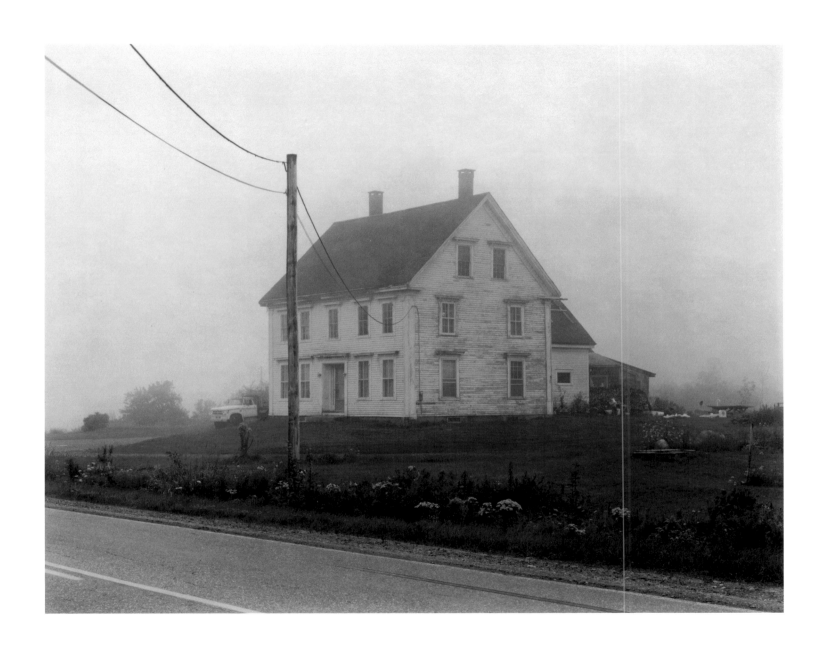

Farmhouse in Fog, St. George, 1982

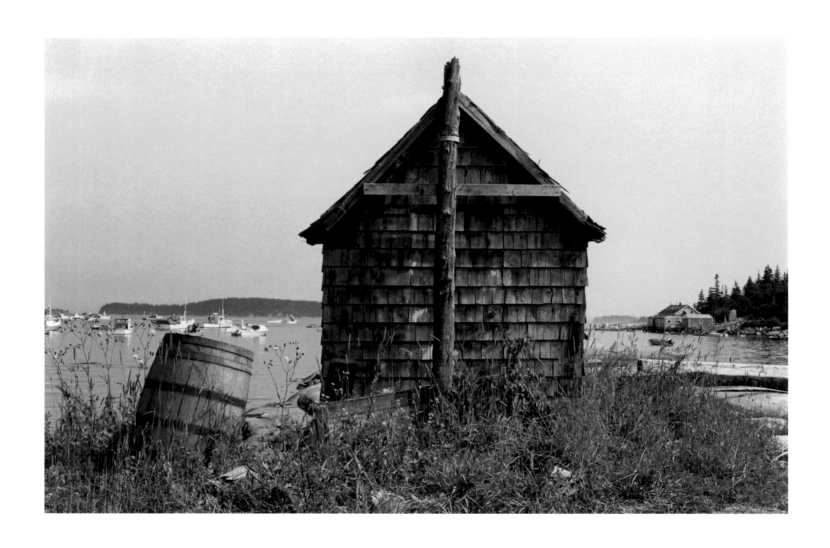

Fish House, Stonington, 1984

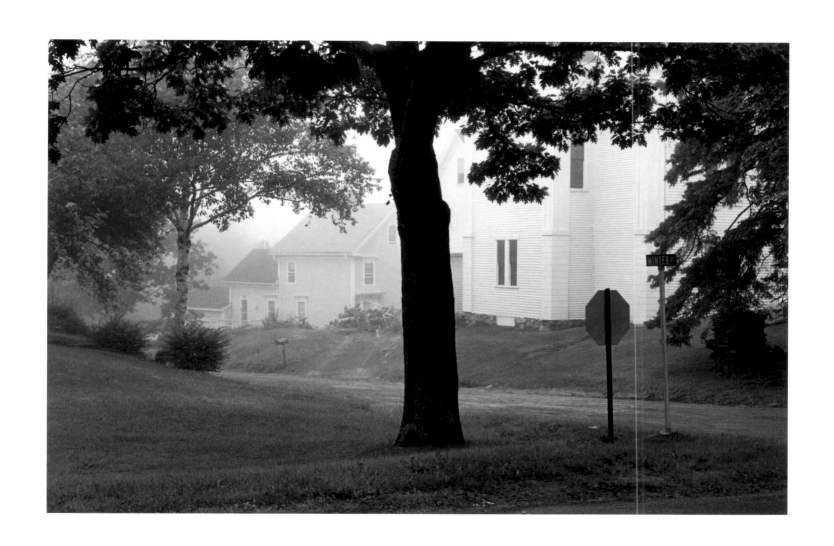

Winter Street, Rockport, 1984

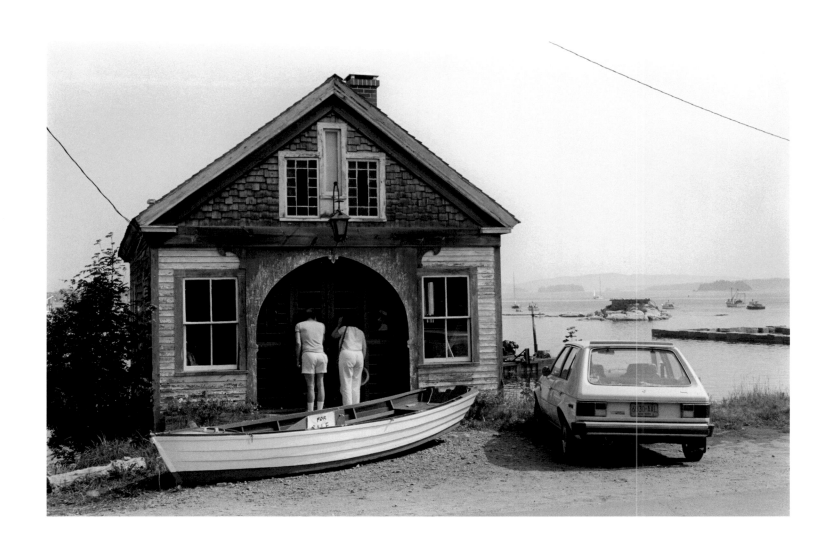

Tourists, Stonington, 1984

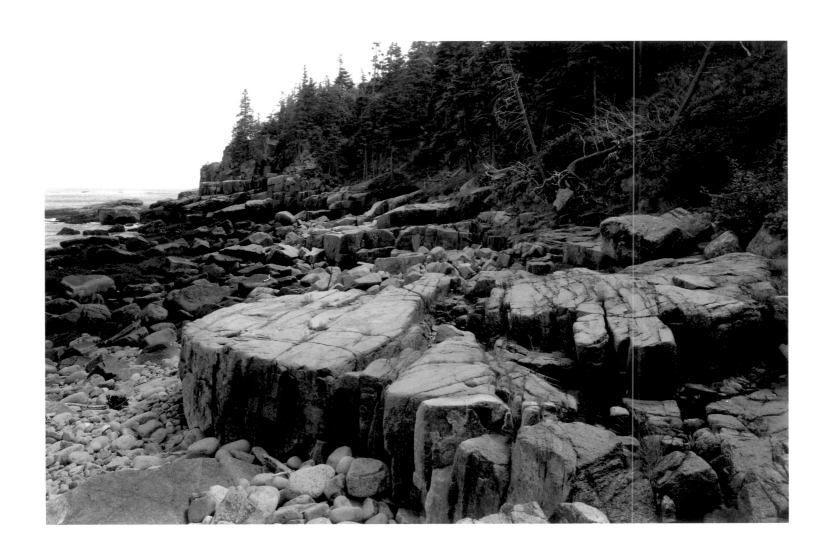

Low Tide, Mount Desert Island, 1989

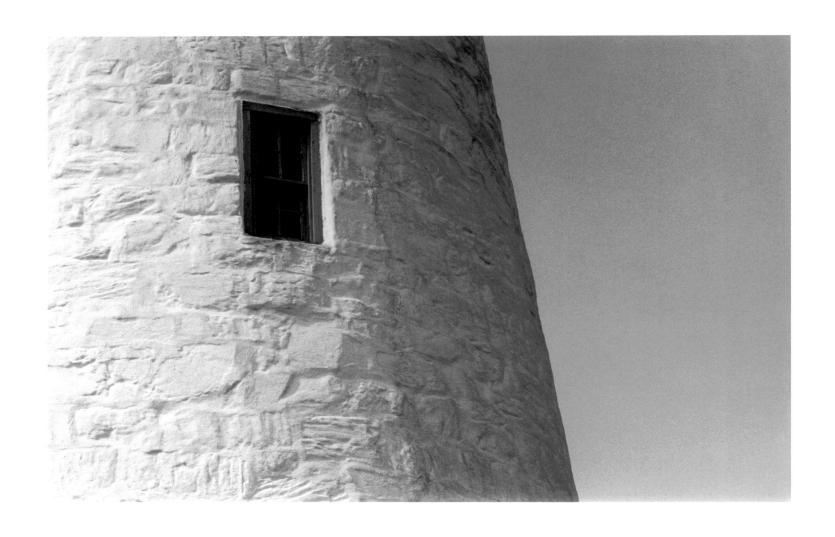

Portland Head Light, Cape Elizabeth, 1995

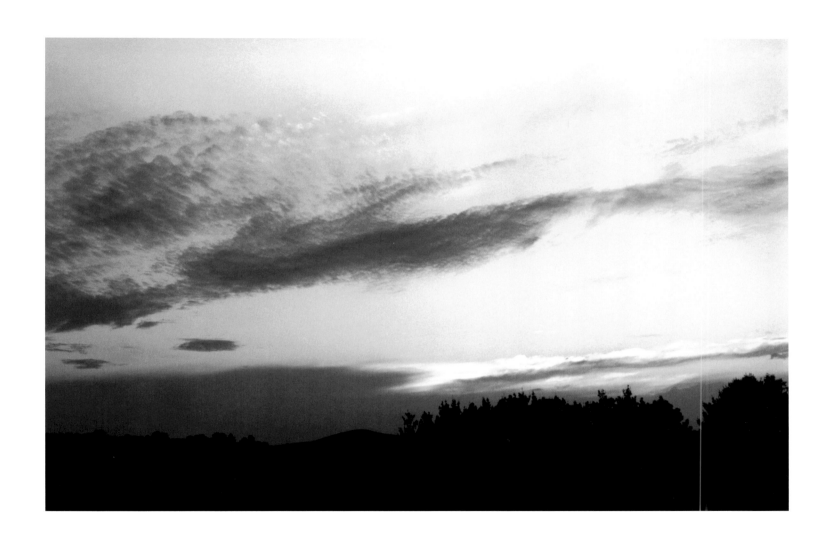

Sunset, Rockport, 1987

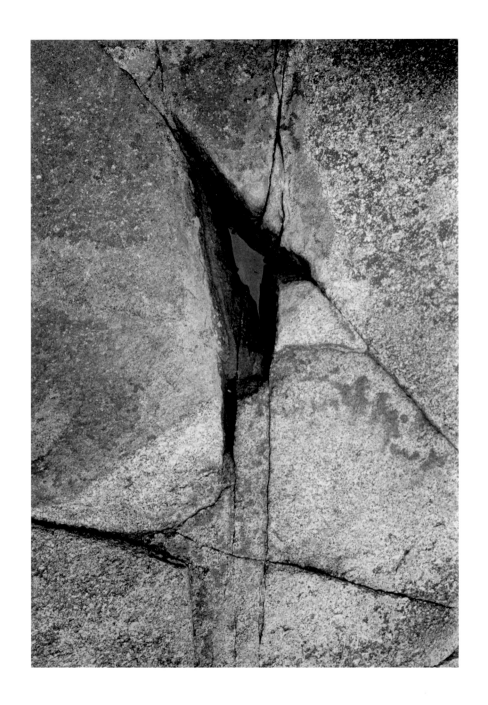

Granite Detail, Mosquito Head, 1995

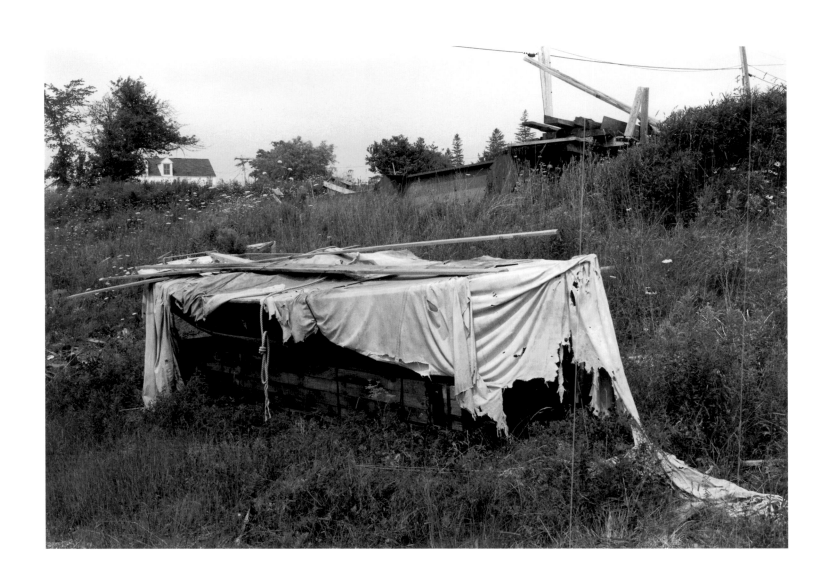

Shrouded Boat, Thomaston, 1994

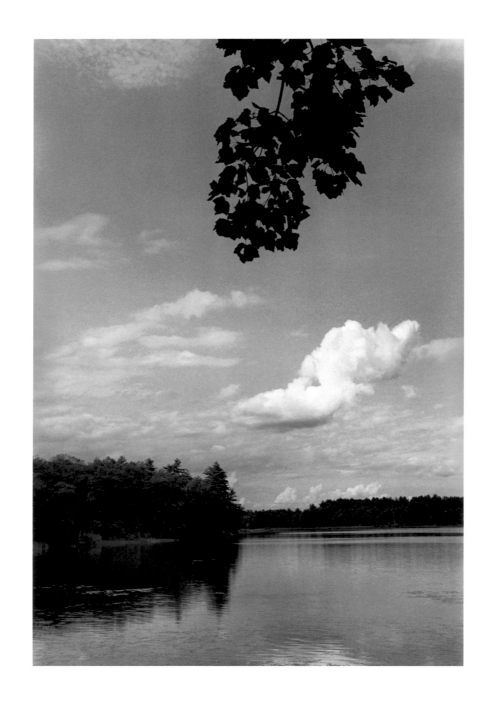

Lake Near Camden, 2000

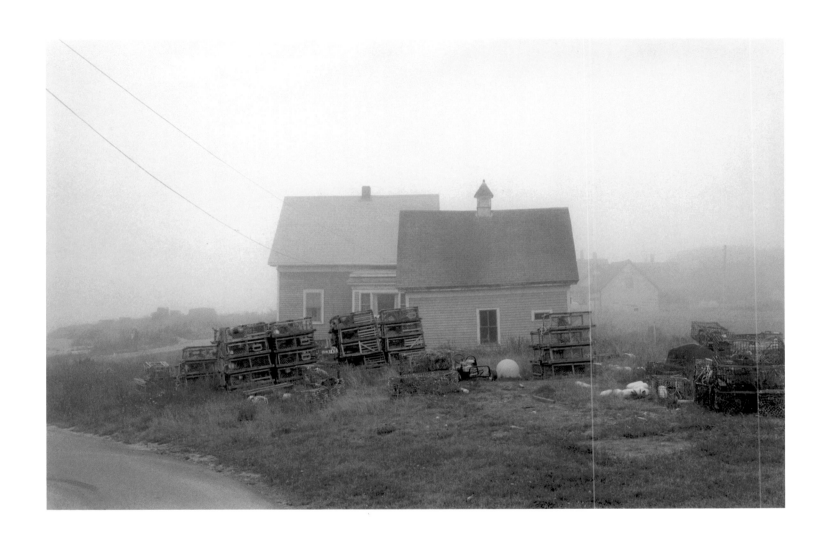

Lobsterman's Cottage, Beals Island, 1999

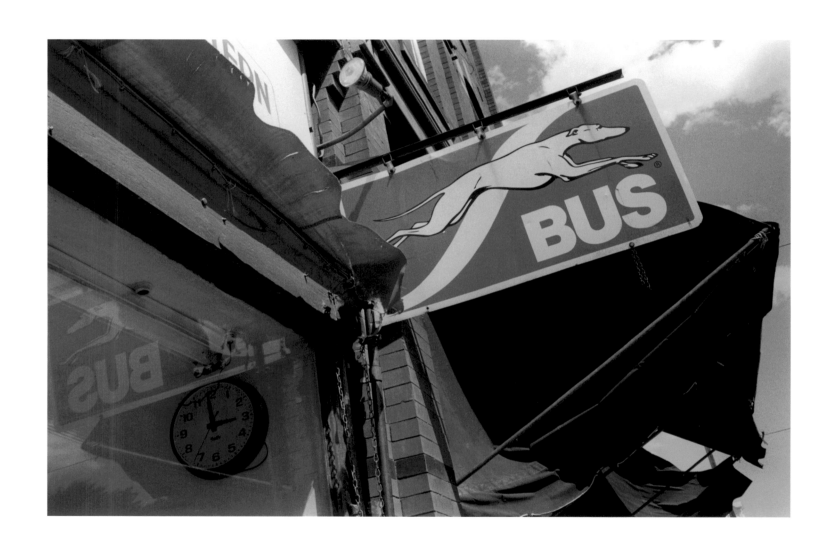

Bus Stop, Belfast, 1990

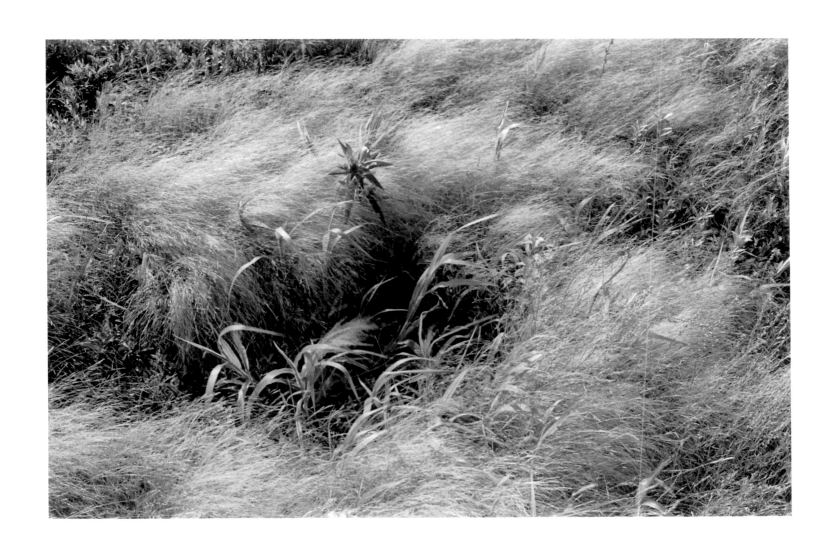

Wind-blown Grasses, Searsport, 2000

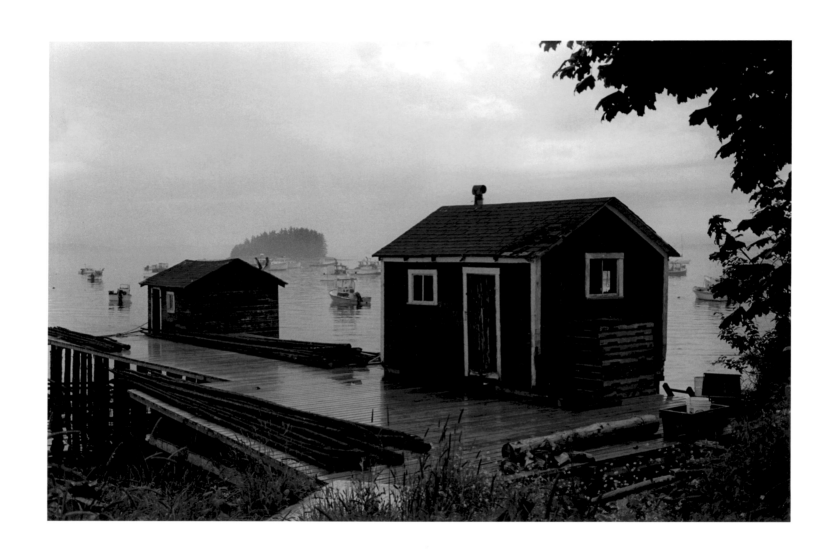

Lobster Shacks, Beals Island, 2000

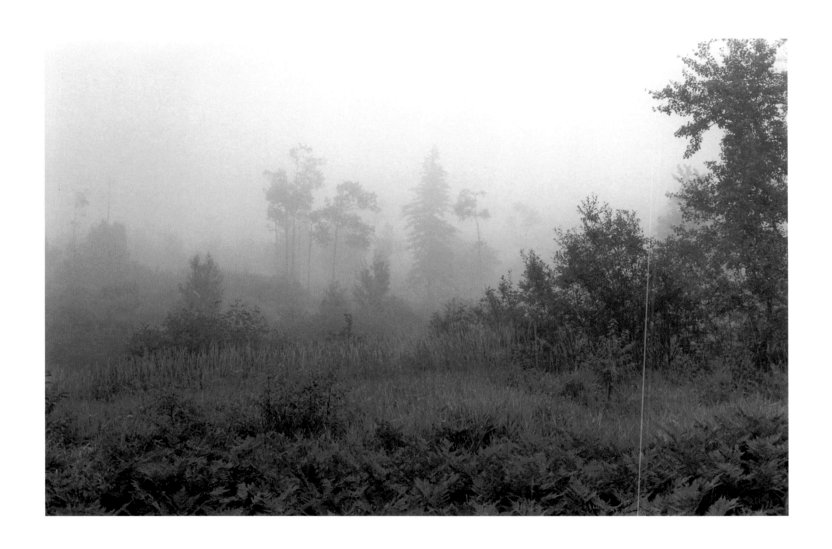

Trees in Fog, Pembroke, 2000

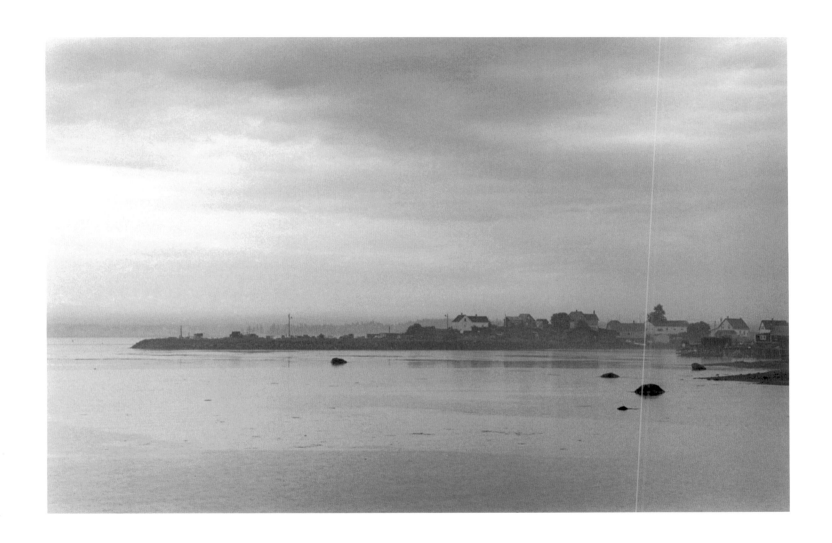

Sunrise, Beals Island, 2000

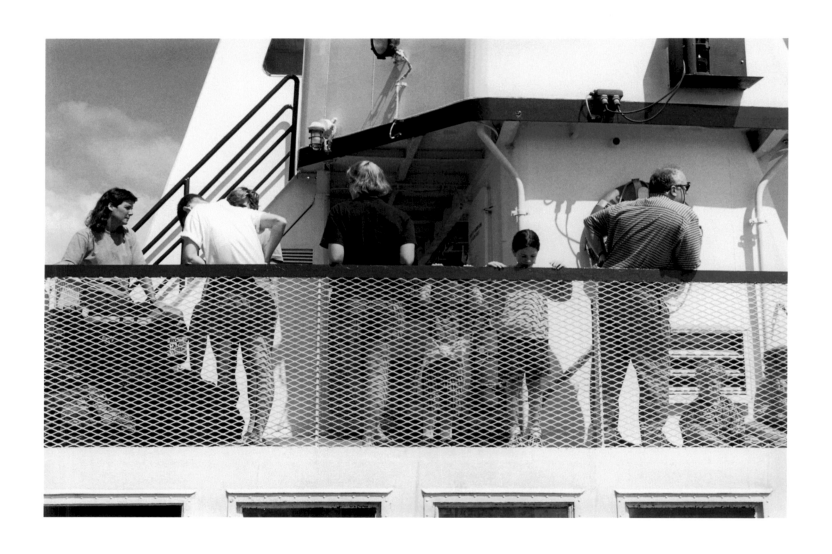

Island Ferry, Rockland, 2000

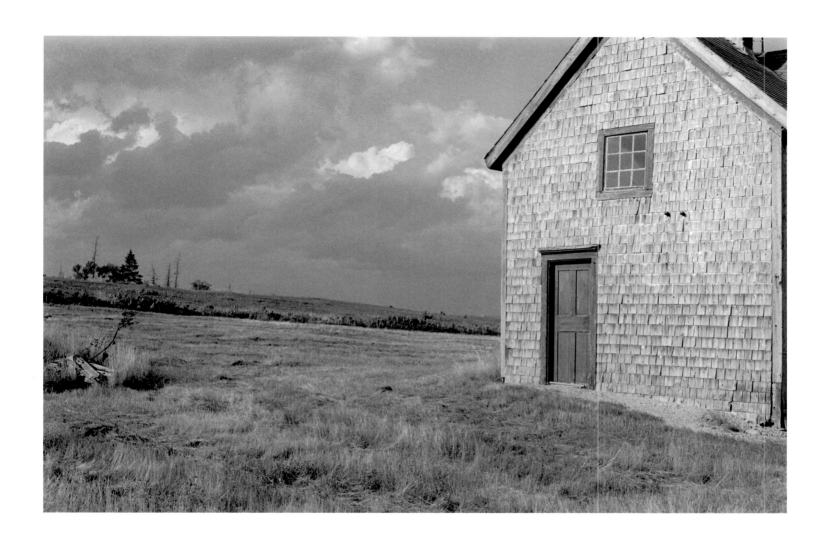

Farmhouse, Lubec, 2000

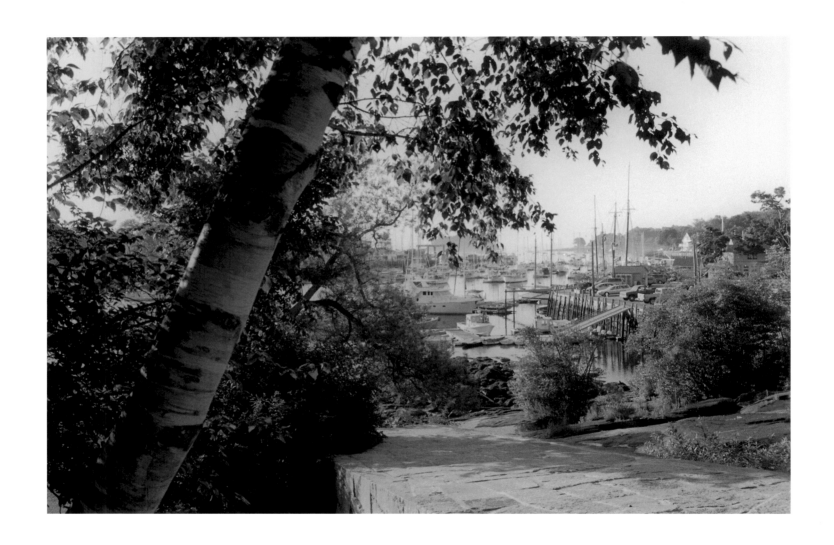

Camden Harbor, 2001

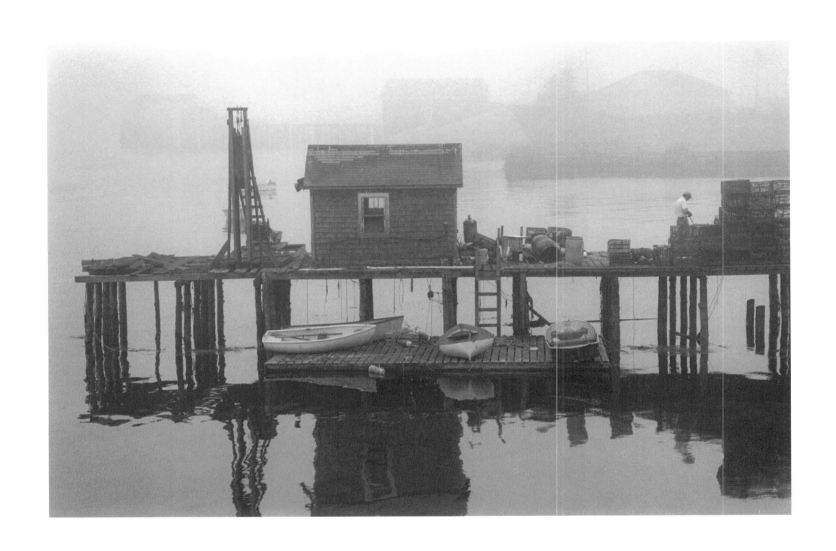

Wharf, Beals Island, 2000

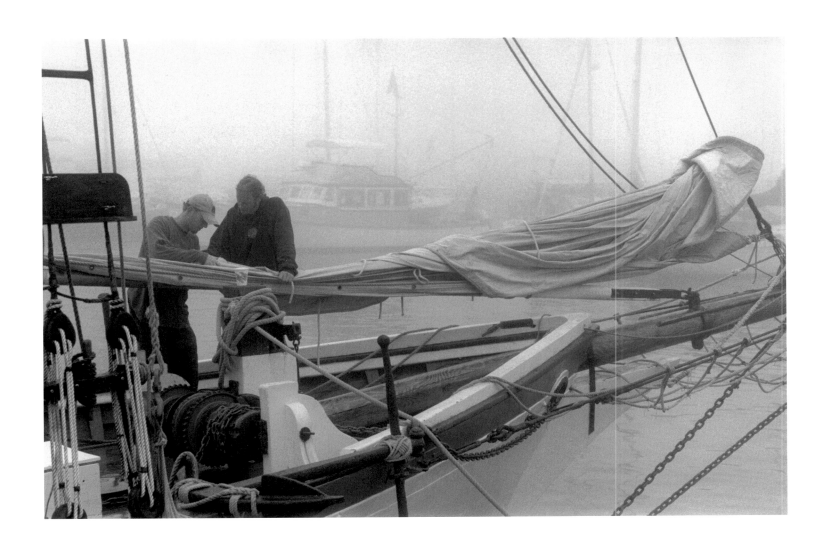

Camden Harbor, 2005

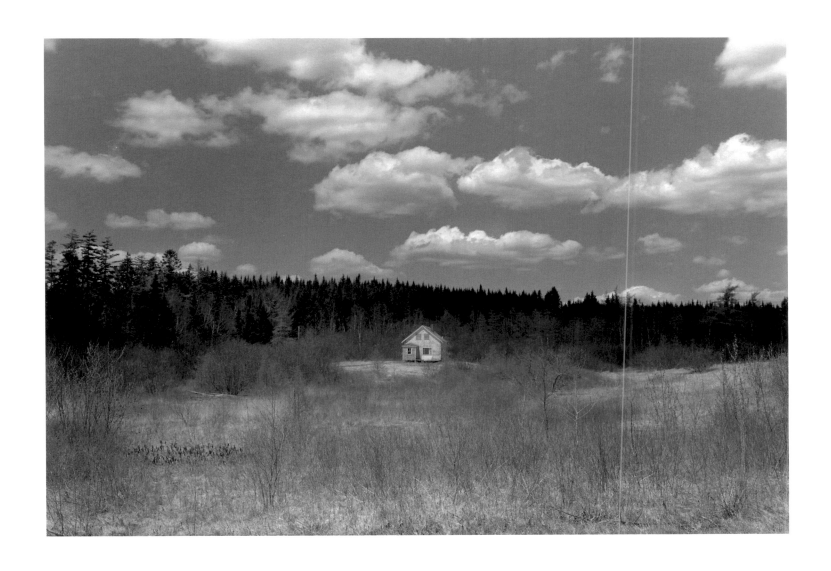

Cottage, East Machias, 2007

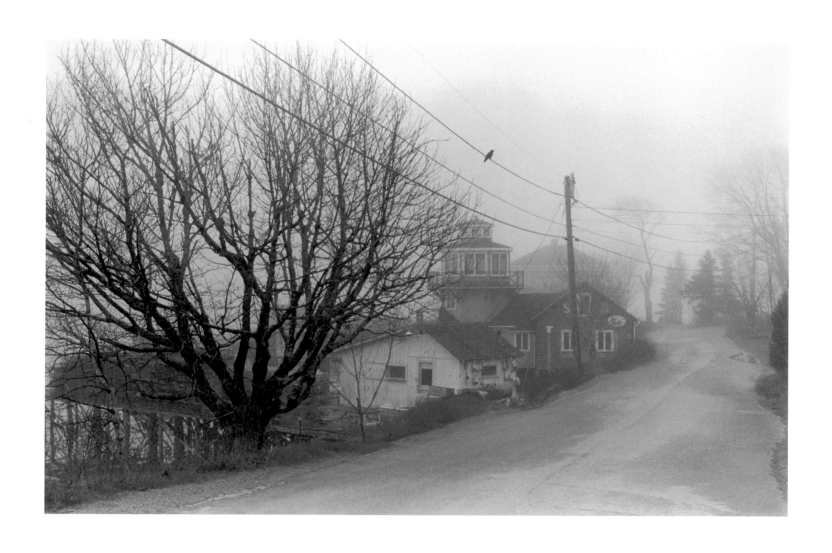

Bird on Wire, Mount Desert Island, 2007

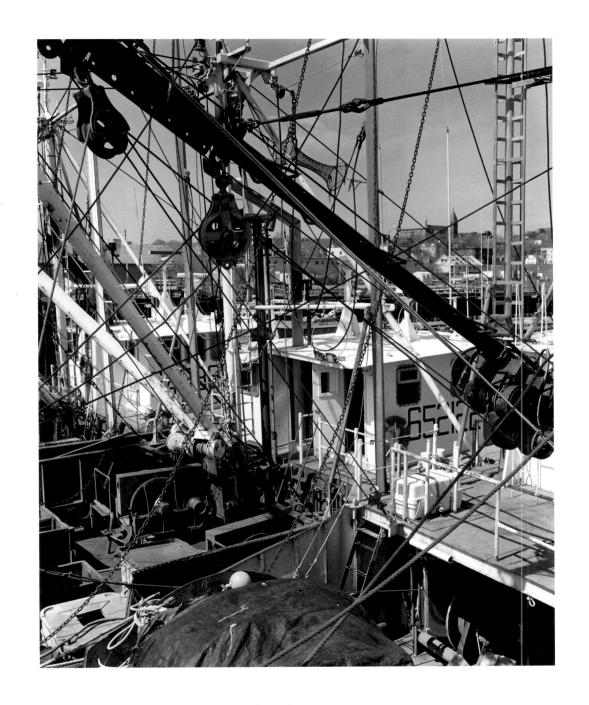

Portland Seaport, 2007

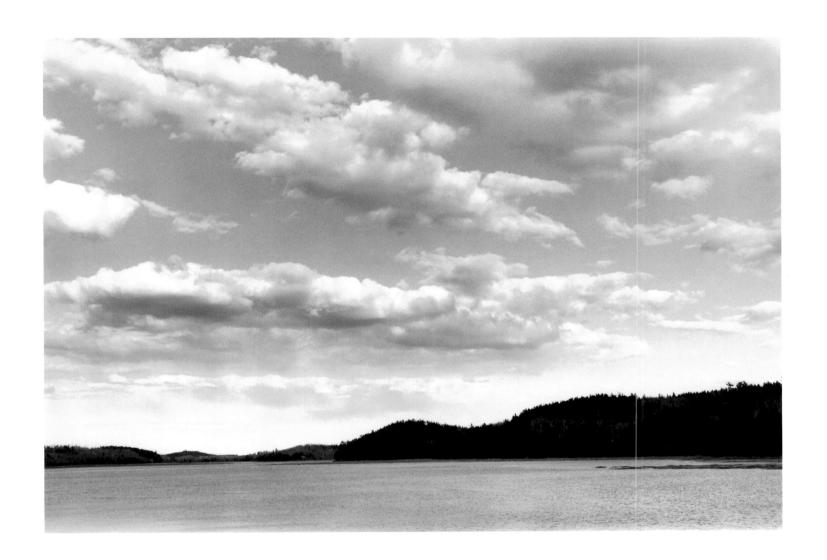

Machias River, Machias, 2007

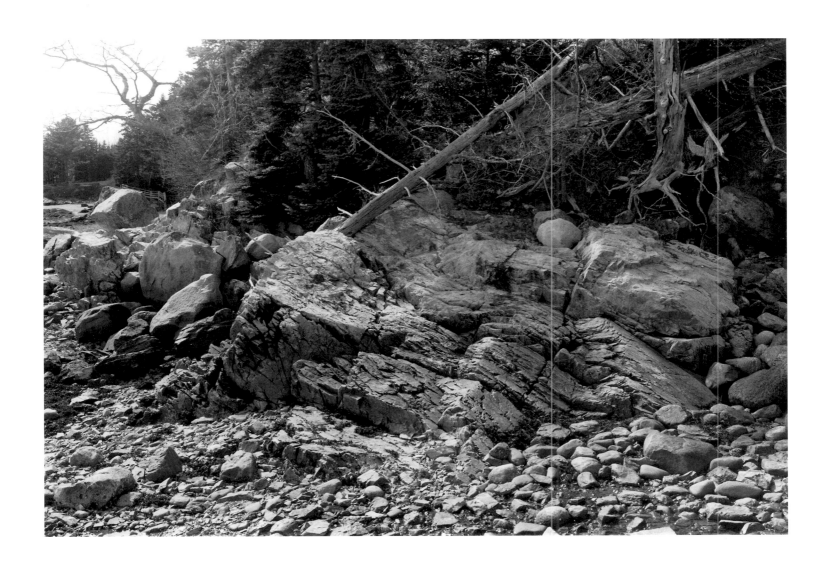

Seacoast, Sullivan, 2007

Ring Bolt, Stonington, 1984

Seacoast Maine

has been set in Monotype Dante, a face designed by the renowned scholar, typographer, and printer, Giovanni Mardersteig, for use at his Officina Bodoni in Verona, Italy. The types were cut in the 1950s by Charles Malin, the French punchcutter whose collaboration with Mardersteig produced a series of distinctive faces over a span of twenty-five years. The Dante type takes as its models the Italian types of the fifteenth century, but the deftness of Mardersteig's drawing and the brilliance of Malin's cutting save the type from the excessive refinement that limits the usefulness of many faces cut for private presses.

Thanks to Claudia Ansorge, Sally Arteseros, Edward L. Deci, Jennifer Delaney, Deborah Delzotti, Martin Dibner, Harvey Dwight, David R. Godine, John K. Hanson, Tom Ives and Lois M. Tristaino of New Hampshire Bindery, August Kleinzahler, Joan LaBanca, Carl W. Scarbrough, Lisa Tice, Earl Tidwell, Marie Tremmel, Bob Tursack of Brilliant Graphics, and Jamie Wyeth.

DESIGN BY GEORGE TICE AND CARL W. SCARBROUGH